THE ANCIENT ART OF TEA

THE
ANCIENT ART
OF TEA

DISCOVER HAPPINESS AND CONTENTMENT IN A PERFECT CUP OF TEA

WARREN PELTIER
Foreword by JOHN T. KIRBY, Ph.D.

TUTTLE Publishing

Tokyo | Rutland, Vermont | Singapore

Published by Tuttle Publishing, an imprint of Periplus Editions (HK) Ltd.

www.tuttlepublishing.com

Copyright © 2011 Warren Peltier

Unless otherwise indicated, all photos were taken by Warren Peltier

Library of Congress Cataloging-in-Publication Data
Peltier, Warren V.
 The ancient art of tea : discover the secret of happiness in a perfect cup of tea / Warren V. Peltier ; foreword by John T.Kirby.
 p. cm.
 Includes bibliographical references and index.
 ISBN 978-0-8048-4153-5 (hardcover)
1. Tea--China--History. 2. Tea--Social aspects--China. 3. Chinese tea ceremony--China. 4. Drinking customs--China. 5. China--Social life and customs. I. Title.
 GT2907.C6P45 2011
 394.1'2--dc22

 2010031889

ISBN 978-0-8048-4153-5

Distributed by

North America, Latin America & Europe
Tuttle Publishing
364 Innovation Drive
North Clarendon, VT 05759-9436 U.S.A.
Tel: 1 (802) 773-8930; Fax: 1 (802) 773-6993
info@tuttlepublishing.com
www.tuttlepublishing.com

Japan
Tuttle Publishing
Yaekari Building, 3rd Floor
5-4-12 Osaki, Shinagawa-ku, Tokyo 141 0032
Tel: (81) 3 5437-0171; Fax: (81) 3 5437-0755
sales@tuttle.co.jp
www.tuttle.co.jp

First edition
25 24 23 22 21 10 9 8 7 6 5 4

Printed in Malaysia 2111VP

Table of Contents

Chapter Five
TEA ETIQUETTE

Chapter Six
REFINEMENT IN TEA

Appendix 1

Appendix 2

Appendix 3

Appendix 4

Dedication

For all who imbibe the spring dew, green nectar may the echoes of the ancients contained here be your inspiration. And especially for Meng-Yao.

Special Thanks

To Dr. John T. Kirby for encouragement and advice from the very start of this book project. Look how far we've come!

To my editors at Tuttle, William Notte and Bud Sperry for their tremendous help in refining and crafting this book into literary tea prose.

To my agent, Neil Salkind, for his encouragement and help in smoothing out the rough spots.

To Dr. Eric Messersmith for his review and endorsement of this book.

To my uncle, the late Tom Peltier, for encouragement and help throughout the draft writing of this book.

To my tea brother, Wang Yu Long 王裕龍, of Wuyi for his endless instruction on the finer points of picking and production of yancha.

To Liu Shan 劉珊, for taking me to the secluded depths of Wuyi mountain, and especially for demonstrating her incredible talent in tasting tea.

To Ren Ling Hong 任玲紅 for brewing endless gaiwans of fresh, fragrant yancha.

To Mr. Zheng Hong Hui 鄭宏輝 of Wuyi for leading me over narrow mountain paths, through thick bamboo forest to view magnificent century-old laocong (old-growth) Dahongpao tea trees.

To Zheng Hong Ping 鄭紅萍 for warmly welcoming us to her ancient wooden mountain home and especially for the myriad wild-harvested flavorful dishes she cooked for lunch; and for the delicately scented mountain tea, freshly produced.

Foreword

Although the majority of my time is spent teaching "the classics" as they have been understood here in the Western world for the past couple of millennia—i.e. Greek and Latin—these days I find myself saying to my students more and more, "Study China. Learn as much as you can about China. China is your future. No—in fact, China is your *present*." It will already be evident to the thoughtful readers of this phenomenal new book that the presence of Chinese culture looms ever larger in Western lives. This book is itself yet another instance of that trend.

But as we also see in these pages, China is profoundly a part of our *past* as well. The reality of this may perhaps not be immediately obvious to all; but anyone, within or without the orbit of Asian culture in its broadest parameters, who is interested in the history and legacy of tea, is by that very fact indebted to literally thousands of years of Chinese history, Chinese economics, Chinese art and aesthetics, Chinese religion and philosophy, Chinese agronomy and botany, even Chinese politics. All of these aspects of Chinese culture bear specifically and directly upon the development of what we may call "tea culture" in China itself, and thus also in Japan and Korea (to which Chinese tea culture, along with Chinese Buddhism and all other things Chinese, was exported), in the British Empire, and eventually in the Americas.

I have at my elbow a cup of tea as I write this. It happens to be a tea that was grown and processed in China. But even a tea from India (or Sri Lanka or Argentina or Hawaii) will have been planted and grown there because of the long heritage and reverence that tea enjoyed first in China. In this sense particularly, China is

our past. And to understand the past, to embrace and cherish what is best and most worthy of preservation, we must learn as much as we can about it.

China's past is exceptionally difficult for Westerners to recuperate. So many things stand in our way: a language barrier, written and spoken; a huge and elaborate nexus of cultural practices that are often opaque or counterintuitive to the Western mind; and, of course, the physical miles intervening between China and the West. It is no wonder that many Westerners resign themselves to a very superficial understanding of the venerable cultures of Asia.

What is needed, then, is a guide: a guide who understands the past and can explain it to the present. Remarkably, modern Chinese may also need such a guide themselves: the combined historical effects of the last century have, in many ways, obscured the amazing past of Chinese culture even from twenty-first-century Chinese. So such a guide will have much to say to East and West alike.

The author of the book you hold in your hands is just such a guide. Warren Peltier, known also by his Chinese name 夏雲峰 Xia Yun Feng, moves between Asian and Occidental cultures with an ease unmatched by almost anyone I know. He has spent years living and working in China, and has gained fluency not only in modern Chinese dialects but also in the often-obscure classical language. His years of poring over ancient texts have given him the kind of intimate familiarity with these authors that cannot be won in any easier or quicker way.

But Peltier's understanding of Chinese tea culture is not limited to the arid perusal of dusty tomes: he has also traveled far and wide in China itself, from the verdant tea farms of the south to the bustling shops of Beijing, spending time with farmers and tea masters and ceramicists and vendors—and, of course, drinking tea

constantly with Chinese of every stripe, for whom this is a fundamental part of their daily existence. With my own eyes I have watched him do all of these things on the Chinese mainland; and over the years he has described many other similar experiences to me, from different tea-producing regions in the Chinese-speaking world.

Peltier brings an extraordinary constellation of experiences to bear upon the venerable texts represented in this book. He knows a great deal about the historical development of tea culture—its growing, its processing, its varieties, its storage, its consumption, and its cultural valences in different times and places—and he knows what today's tea drinkers, Asian or Occidental, are likely to want to know about such things. But above and beyond all this, Peltier's scholarly approach is quite rare in the world of tea publication, even today, whether in Asia or in the West. He has carefully studied the classical forms of the vocabulary of these treatises, including characters that are archaic or obsolete—characters that would be unfamiliar even to many modern native readers of Chinese. He has thought about the practices of tea preparation and consumption that these texts describe, with reference both to their historical context and to the tea cultures current today. And these philological and cultural sensibilities equip him to explain what he sees in these texts with a clarity and immediacy of which very few others working in this field are capable.

As a classicist in the Greco-Roman tradition, I am particularly sensitive to these sorts of problems, and alert to the spectrum of proposed solutions to them. In classical scholarship as it has been disciplinized in the West, we have seen a long trajectory (since antiquity itself) toward various types of *exactitude*. New technologies have enabled Occidental classicists to make enormous strides in understanding what it was to live in the ancient Mediterranean world: indeed such technologies

have played a vital role in that progress, marking (as they do) massive sea-changes in the discovery, dissemination, and consumption of knowledge. One of the most monumental events of the Renaissance—I think we could reasonably designate it as one of the truly *constitutive* moments of the Renaissance—was Gutenberg's use of movable type. This technology made possible the reproduction, at an unprecedented rate of speed and level of accuracy, of books that were now printed rather than being copied laboriously, one by one, and by hand. The development of the printing press gave rise to a whole new industry of scholar-printers, humanists who cared passionately about the texts they were studying, and who wanted to make them available to a wider reading public. As such, they were some of the most important educators the West has ever known. The Internet, meanwhile, is arguably the single biggest leap in information technology since Gutenberg, though (interestingly) it has not caused the disappearance of the printed book. What it has done, however, is greatly to fluidize the concepts of reading and "publishing"—and to expand their possibilities.

Western classical scholarship grew to adulthood largely in the period between the births of those two technologies. Chinese classical scholarship in its dissemination to the West, on the other hand, is the heir to both of them: movable-type printing and the Internet have both played incalculable roles in the modern Asian education of the West (and, for that matter, of Asia itself).

To become expert in an ancient literary tradition means to become familiar, not only with the authors and texts of antiquity, but also with the various extant manuscripts and printed editions of those texts; moreover, to some degree at least, with the procedures by which a modern printed and/or digital edition must be produced.

For Western classical studies, because of the vast quantity of manuscripts dating from our Mediaeval period and earlier, and because of the very difficulty of reading those now, this entails a highly recondite set of skills, and represents a daunting project even for the trained classicist. In Chinese philology as practiced in the West, a few of the principal classical texts, such as the *Daodejing (Tao Te Ching)*, the *Analects* of Confucius, and the *Yijing (I Ching)* have received the kind of philological scrutiny familiar to classicists of the Western tradition, and their extant sources have been collated into modern critical editions, documenting textual variants in the ancient manuscripts and proposing conjectural emendations. For the most part, however, and despite an ancient and massive philological tradition in Asia, these practices have yet to become standard in the Occidental study of classical Chinese literature. Where Peltier stands with this current book is approximately where those great scholar-editors of the Renaissance stood: consulting original texts, making careful vernacular translations of them for modern Western readers, and setting the stage for the most exacting philological investigation, word by word and line by line. He has set that fuse alight, and I predict an explosion of the most exciting and productive kind. In the years to come, we are going to see a tremendous proliferation of scholarly research being published on the history and development of tea in Asia; but the scholars who produce it will have Peltier to thank for blazing this trail ahead of them.

John T. Kirby
Professor and Chair
University of Miami, Department of Classics

Preface

Study of the ancient art of Chinese tea can further advance the modern study of tea. The tea classics in this book were written in the period spanning from 1,200 to 350 years ago. While writing this current work, it was not my purpose to translate whole texts, but rather to gather similar information together, to provide a comparison and more in-depth study of the topic chapters in this book. More specifically, this book demonstrates the variety of tea brewing skills in ancient times. Much of this knowledge can be directly applied and used in tea preparation today.

The ancient art of Chinese tea varies widely depending on the time period because teas, tea utensils, brewing methods and techniques evolved over time from the Tang, Song, Ming, and Qing dynasties. The excerpts translated from these tea classics date from these dynasties, a period spanning from the year 780 to 1655.

While I have not provided full translations here (as that would take entire volumes and decades of work), one entire tea classic is fully translated within this book: *Chronicle on Water for Brewing Tea.*

Study of these tea classics is important. We learn that not all ancient tea masters were in agreement on things such as the finest sources of spring water, or types of fuels for a tea fire. Skill and technique in the ancient art of Chinese tea varied from one tea master to the next.

Some classical tea book writers were not authors but compilers. They gathered similar information from previously written classical tea manuscripts and other historical documents; not unlike the format of this book. However, their work was important: they helped preserve information from now long-lost texts for our benefit, furthering and deepening our understanding of ancient tea culture.

Much of the information within this current work may be new to English readers. And even in Chinese, modern scholarship on the subject is somewhat deficient. So there is no tea book quite like this one. The publishing of this book, the first of many to come, will help readers find useful and valuable information in their study of tea.

A NOTE ON THE TRANSLATIONS

Classical Chinese is a very concise language. Texts are sometimes vague and ambiguous, containing implied meanings or obscure references. Many translations of Classical Chinese texts are available in English and, if you compare them, every translation is different—sometimes vastly different. Some translators take creative license in translating works by adding many embellishments not present in the original. While others are so rigidly translated that they miss or omit much information either present or implied in the original.

In translation, I stayed as close to the original as possible, although it was necessary for me to interpret some of the texts. Where I had to interpret what

was not in the text or add to it, this was done only to provide clarity of meaning. In the main text, I sometimes added in extra words for clarification, these are indicated in round brackets. I also included many notes for clarification and added commentary to complement the translations.

In keeping with modern standard Chinese, all transliterated terms are in Pinyin. And for further clarification, the original Chinese characters for these terms are in the notes. I chose to use Traditional Chinese characters, which are commonly used in North America.

Where published translations are readily available, I did not use them. Instead, I translated all the works in this book myself. This gave me freedom to translate and interpret the text in the spirit of tea and make the texts or passages relevant to the study of tea. In this way I am not bound or colored by one version or one particular translation. Besides the translations, I also included the original Chinese texts for those readers seeking deeper knowledge.

I hope these translations, many of which have never before been translated into English, provide clear insight into Chinese tea culture and help to foster a deeper appreciation of tea.

THE BOOK

In writing *The Ancient Art of Tea*, I spent three years traveling throughout Fujian to Anxi, Dehua, Wuyi and many other areas noted for tea, while experiencing and absorbing Chinese tea culture. Then, for over a year, I secluded myself

in my forest home, living as a recluse (much as ancient scholars did), pondering and studying ancient tea knowledge. My entire life was consumed with only one thing: tea. *The Ancient Art of Tea* came about after spending numerous months, often working 12-hour days persistently researching and writing. I had to endure great sacrifice in order for this book to come to fruition.

Why would I write such a book? I wanted to introduce English readers, and especially tea connoisseurs, to what is for me a profound love of tea and a passionate interest in Chinese tea culture.

In so many ways, my whole life revolves around tea. I spend waking hours drinking tea, researching obscure aspects of tea culture and talking to tea friends and tea professionals about tea. My free time is also spent with tea friends, leisurely drinking tea, of course. At night my dreams are filled with tea themes. When I can't sleep, it's often because I thirst for yet another cup of that magical infusion.

Tea is a journey that has taken me across continents and to distant places, where I can hear the echo of the ancients who would say: "Bring on another bowl of tea."

In China, while reading these ancient tea texts, it struck me that each successive writer had a little bit more information to add; elaborating on what earlier tea writers observed. I felt it would be wonderful to gather all of this information and put it into one volume for the benefit of everyone.

In the West especially, little is known of these ancient tea books. And even in China many of my tea friends possess only scant familiarity with the contents of these books, yet when I raise the subject of water or fire they can imme-

diately tell me their own specific procedure. Centuries of study on the subject produced many different techniques and skills for tea brewing and preparation, yet we are unaware of how they arose.

Some readers may be familiar with the "God of Tea," Lu Yu, and his *Classic of Tea*, but what did other tea masters of the same or later periods have to write about tea brewing and preparation? This book is a record of what they said.

I sincerely hope readers will find the ancient tea knowledge in this book a useful aid in their study of tea. And through it, may we all together relax and enjoy another cup of the fragrant leaf that is tea.

Warren V. Peltier (Xia Yun-Feng 夏雲峰)
Fuzhou, Fujian, China

A Brief History of
Chinese Tea Drinking Customs

To put *The Ancient Art of Tea* into perspective, we have to bear in mind that tea culture, drinking practices, tea utensils and teas themselves, all changed over a long period of time. In many respects, the teas, tea utensils, and brew methods in the Tang, Song, Ming, and Qing periods were dissimilar yet some elements were similar.

The Tang saw coarse brick tea of steamed green bricks, which contained a rice paste binding agent. As part of the tea brewing process, these bricks were pounded into chunks, roasted over a low fire to remove the moisture, and then milled in a stone mill to a fine powder. Water was boiled in a cauldron while the correct temperature of the boil was determined by viewing the bubbles forming in the pot. Just at the right moment, milled tea powder was added to boiling water and seasoned with salt.

In the Song Dynasty, steamed green bricks were still popular, but Song Dynasty people had higher requirements for their tea. They favored pure tea without additives. The fine bricks were still pounded and milled to a fine powder, but the tea wasn't boiled as in the Tang Dynasty, instead water was boiled in a spouted ceramic bottle. The correct water temperature determined suitable for fine green tea powder was sensed by listening to the sounds of the bottle. The

powdered tea was then placed in a preheated bowl. Froth was produced on the tea while alternately pouring water from the bottle and beating the tea with a tea whisk or spoon. Song Dynasty Teaists put great value in producing a white froth on top of the green powdered tea. For this reason, black glaze tea bowls were favored the most because of their great contrasting effect.

By the Ming Dynasty, powdered green tea fell out of use in favor of a more convenient method: direct steeping of whole green tea leaves in hot water. This led to the development and further refinement of *gaiwans* and teapots both of porcelain and *zisha* clay as steeping vessels.

At the end of the Ming and into the Qing Dynasty, a further refinement in steeped tea, the brew method of gongfu tea, where small teapots and tea cups were used to steep fine tea came into popularity in southern Fujian and northern Guangdong provinces. The rise of gongfu tea came into practice as a new tea type. Wulong or oolong tea became developed in northern Fujian during the same period.

Many classical tea texts follow a similar format to Lu Yu's *Classic of Tea*. In writing this book, I wanted to bring together much of the similar information from a variety of ancient tea texts to give us a broader perspective and deeper insight into topics such as water for tea, heating the fire, boiling the water, the philosophical taste of tea, etc. From these, I hope readers can gain an understanding of the great skill the ancients possessed in brewing their tea. We can also glean some techniques or knowledge that we may find useful in preparing and appreciating tea to the fullest.

The Art of Tea

More than three millennia ago in China, tea evolved from a medicinal drink or vegetal food into a singular beverage. Later, over 1,200 years ago during the Tang Dynasty, Lu Yu wrote the *Classic of Tea*. In his tea book, Lu Yu lists the tools to manufacture tea, he describes the utensils to prepare, brew, and serve tea. Lu Yu ranks different kinds of water based on their suitability for tea. He details how fire is correctly made and how water is properly boiled. He argues how tea is best drunk and enjoyed. In the volume Lu Yu created, the first surviving tea book in existence in the world, he laid out much of what was required of tea drinkers to know at that time. Many modern Teaists contend that Lu Yu was the first to describe the act of producing, brewing, drinking and enjoying tea as an art form. Precisely because of Lu Yu's excellent work in writing such a noble volume, the use of tea as a beverage became popularized in the Tang Dynasty and subsequent eras, leading to tea becoming a common worldwide beverage.

However, not until the Song Dynasty did tea drinking become much more intertwined with art. Fast-forward to today, and Tea Art, or *Chayi*, a new concept adapted from the ancients, is widely practiced and enjoyed in China by millions and is quickly increasing in popularity.

THE NATURE OF TEA

Tea is a natural product. Clouds and mist nurture the tender green buds or leaves in the mountains. Tea bushes are watered by sky, nourished by rock and soil. When tea bushes grow tender sprouts, they resemble a sparrow's tongue: small and narrow. Many Chinese teas embody nature in their being. They may have names suggestive of nature, such as "green snail spring," "melon seeds," "bamboo leaf green," "clouds and mist," "purple bamboo shoot," and "sweet dew."

The ancient Chinese held tea in high regard for its medicinal and rejuvenative properties, such as aiding digestion, banishing sleepiness, restoring vitality, and uplifting the spirit. They prized teas that grew high on the mountains, in crags and crevices in the rocks. They also believed that tea was best brewed with pure, clean, mountain spring water thereby increasing its efficaciousness. Further, they believed the best way to enjoy tea was to imbibe the nectar under a rustic pavilion in the mountains surrounded by bamboo thickets and pine forests, while viewing mists floating between mountain summits and listening to the buzz of cicadas in the trees. Nature was and is an integral part of tea.

Today, tea practiced without natural elements seems devoid of tea spirit. We therefore incorporate natural elements to make teatime more enjoyable: we may use tea utensils made from natural wood, stone or bamboo. We might also place a flower, plant or even an interesting stone on a table nearby to add nature to our tea experience. Even water boiling in the kettle sounds as though waves are crashing, or wind blowing in the pines. Nature is an indispensable part of tea. There is tea in nature and there is nature in tea.

ORIGINS OF TEA

To write about the origins of tea would take a whole volume. Instead, since this book is about the art of Chinese tea, let's examine the artistic origins of tea.

In the *Classic of Tea*, Lu Yu lists many tea characters:

Of the names, one is called *"cha"*[1], two is called *"jia"*[2], three is called *"she"*[3], four is called *"ming"*[4], five is called *"chuan"*[5].

During the Tang Dynasty there were at least five common characters for tea, but why are there so many names for tea? Lu Yu explains in chapter 7 of the *Classic of Tea,* where we find included references from other ancient books or records. Three of these references explain the various meanings of each tea character. Here is what the *Classic of Tea* records:

Duke of Zhou's Er Ya:
Jia *is bitter tea.*

The *Er Ya* is an ancient dictionary containing reference to *jia*, so any bitter tea is called *jia*.

Dialects:
Southwestern Shu people call tea shc.

1. Southwestern Shu[6] is today's southern Sichuan province. In their local Shu dialect, tea was called *she*.

Guo Pu's *Annotations on Er Ya* says:

> When the tree is small, it resembles a gardenia. It grows in winter. The leaves can be boiled to make soup to drink. Today's people call early picked *cha*, late picked is *ming*. Or another is *chuan*. Shu people call this bitter *cha*.

Tea is described as an evergreen tree. Tea is also a vegetable added to soup. Today, we normally regard early picked spring green tea as the finest, and later pickings as lower-quality tea. But keep in mind that these conventions came much later in time. In the warm southern regions, tea may be picked four times a year; so early picked here may not necessarily mean early in the spring. In fact, it probably refers to early in the year (i.e., winter tea) as opposed to spring tea, when the weather warms enough for the tea plants to put forth new shoots.

It's interesting to note how many different words for tea existed during the Tang Dynasty. As evidence of the degree of development of tea in ancient China, this was arguably just the starting point in the long history of Chinese tea culture.

In tea poems of the Tang and Song dynasties, we begin to see poetic metaphors and allusions for tea. Praise and esteem were copiously bestowed on tea with many different names appearing as eloquent, pleasing poetic synonyms for tea.

In the Tang Dynasty poem, "Big Cloud Temple Tea Poem" by Lü Yan[7], we see two poetic terms for tea:

Jade Flower Bud One Spearpoint is called a masterpiece. The monks' creative method is a masterstroke of *gongfu* (skill).

"Jade Flower Bud" is a metaphor for a fragrant tea bud the color of white jade—the fine, downy white hairs give the buds a milky white appearance. But not only does the poet liken tea buds to a fragrant flower, he likens tea to fine jade, showing the value or worth of fine tea. One Spearpoint[8] means a tea bud only. Teas made using buds only make the most delicate, tender and finest tea. In a similar vein, Flag and Spearpoint[9] is what Chinese poets referred to as one leaf and one bud. Flag and Spearpoint also make a very good quality tea. Sparrow's tongue[10] is another poetic way of saying two leaves and a bud, which makes a very good tea too.

In a Song Dynasty tea poem by Li Xu Yi, he pens the following verse[11]:

Shi Ru is a mark of rare quality. Jade Flower is ground creating fine patterns (in froth).

Shi Ru[12] was a famous Song Dynasty Tribute tea of the Wuyi area of Fujian; which was a very excellent tea; so excellent that the Emperor declared it an Imperial Tribute item. *Shi ru* means stalactites, a descriptor for the tea buds, which on the tea plant, possess a narrow and pointed shape. However, since it's the name of the tea, we will continue to use Shi Ru. Jade Flower or "Qiong Ying"[13] was a poetic name of praise for Shi Ru tea.

In another Song-era poem by Song Xiang, we see the following verse[14]:

Thick Clouds overflow the teacup.

Thick Clouds[15] is what the Tang and Song poets penned as a name of admiration to their tea drink. When the tea was boiled or whisked in a bowl, there was white tea froth floating on top of the tea. They likened this froth to beautiful thick white clouds floating in the sky. Afterward, Thick Clouds then became a common metaphor for beverage tea. Thick Clouds first appeared in a poem by the late-Tang era poet Pi Ri Xiu.

Another Song tea poem by Mei Yao Chen expresses the following[16]:

Again appear Eagle Claws and Dew Buds.

Eagle Claws[17] is a reference to the shape of the tealeaves: they are thin and curved like the claws of an eagle. Dew Buds[18] obviously refers to the tea buds; picked early in the morning.

Poetic imagery is conjured up in literary terms for tea: Jade Flower Bud, One Spearpoint, Jade Flower, Thick Clouds, Eagle Claws, Dew Buds. These poetic titles form some of the basis for the artistic origins of tea, and at least, the artistic origins of many tea names. Shi Ru, for example is used over and over in tea poems as an allusion for fine tea, though it was originally the name of a particular Song Dynasty tea. Thick Clouds is also oft repeated in poetic verse as a metaphor for a fine, delicious tea infusion.

In ancient times, much poetic charm and artistry was applied to tea in ei-

ther the names of specific teas or in literary titles and metaphors for tea. The modern art of Chinese tea draws upon these three millennia of tea-inspired poetic and artistic traditions.[19]

THE FUNCTION OF TEA IN SOCIETY

Tea has an explicit purpose in society. Besides quenching thirst or imbibed as the elixir of longevity known for its myriad health benefits, tea has other important functions in society.

The wonderful delight that is tea is found not just in the tea's collective components of color, aroma, taste, and shape. It is the ability of tea to warm the heart, to give us joy and relaxation, to calm us, to purify our minds in the fragrant steam wafting from our cup.

Throughout the world, tea serves as an instrument allowing individuals to interact with each other. We so welcomingly embrace the ever-flowing teapot and infinitely containing teacup which serve as vehicles for mutual discussion. This is a universal function of tea in society.

In China, tea has many other important societal functions. Tea becomes an integral element of social intercourse. When visiting an office, or someone's home, tea is always offered as socially necessary etiquette. Then, host and guests may sit around a cup of tea to discuss whatever issues are raised. Quite often, business deals are signed or problems are solved over a cup of tea.

Tea also serves as the ideal gift to give to friends or family members. Just

as in the West, when someone brings wine when invited to dinner, in China, one could present a bottle of wine, but a better choice is a package of tea. Fine teas are valuable and precious; and when presented in a fancy, decorative box or packaging it becomes a prestigious item. Presenting a fine gift of tea to your friend or host is seen as showing your esteem toward that person. Moreover, tea is viewed as a cultured gift.

During Spring Festival or Chinese New Year, tea also serves as an important present to give to family members. A custom during Spring Festival is to present hosting family members with a gift of decoratively packaged fine teas as a way of welcoming in the New Year and as a token of gratitude and appreciation.

Tea has an important function in weddings too. Families often arrange weddings discussing the prospective marriage over a cup of tea. Several packages of tea may also be offered as a wedding gift to the bride's family. During the Chinese wedding ceremony, the bride and groom kneel down before their parents to respectfully serve them a cup of tea as a sign of filial duty.

Tea's other functions in society are all examined in greater detail in Chapter 5.

THE ART OF TEA IN ANCIENT TIMES

Ancient Chinese never left written records of the modern term *Chayi* or Tea Art. Instead, we see the term "Cha Dao" or "The Way of Tea" in use since the Tang Dynasty. However, in the Five Dynasties, or Early Song era, there was a Teaist

named Tao Gu who recorded in his book, *Record of Chuan Ming* the following:

Liquid Enchanter

Monk Wu wrote about brewing tea. In traveling to Jiang Nan[20], Gao Bao Mian conversed about tea with Ji Xing. They rested at Purple Cloud Hut. During the day, they tasted the art there. Bao Mian, both father and son (referring to Gao Ji Xing and Gao Bao Mian) were called the Gods of Tea.

Creating Tea Bowl

In preparing[21] tea, changing images were conjured on the tea surface (the froth). The Tea Artisan possesses the artistic skill of gods. At Sand Gate were piled prizes, upholding the Will of Heaven, awarded to Golden Village, as long as a Tea Ocean. In whisking tea, he was capable of pouring hot water to conjure tea, to take the shape of a poetic verse. Together, four bowls of tea were poured (whisked); (the froth was parted which) altogether created one superb verse; floating on the tea's surface.

The precise meaning of art reflected here is the art of brewing tea. Tao Gu anecdotally records that in pouring and whisking a bowl of powdered tea, both master and disciple skillfully produce such exquisite art in white-jade froth that they truly are Gods of Tea.

These passages exemplify the artistry of tea in ancient times. Ability to conjure shapes on the tea's surface with a tea whisk was considered not only great skill, but also fine art. At the same time tea masters practiced artistry in brew-

ing and whisking a bowl of tea, they composed tea poems to commemorate such events. So tea drinking in ancient times was a very artistic experience. Today's *Chayi* or Tea Art is a continuation of that sentimental feeling of the tea aesthetic.[22]

CHAPTER TWO

Water for Tea

THE IMPORTANCE OF WATER

A Ming Dynasty document, *Written Conversation of Plum Blossom Herbal Hall*, crystallizes the essential importance of water for tea. It states:

"The inherent quality of tea must be expressed in water. When a tea that is an eight meets with water that is a ten, the tea is also a ten! When water that is an eight pairs with a tea that is a ten then the tea is just an eight."

This premise is very true: water of the highest quality expresses the best qualities of a tea infusion. Therefore, when lower quality tea is brewed with high quality water, the resulting infusion is of high quality. On the other hand, when superior quality tea is brewed using inferior water, the resulting infusion is inferior. Water directly affects the flavor, aroma, and color characteristics of a tea infusion. Superior quality tea when brewed using inferior water essentially ruins the tea, illustrating the need for water of the highest quality in steeping fine tea.

For this reason, in ancient China, many tea masters traversed the coun-

try sampling and evaluating the water of numerous springs, rivers, wells, and other water bodies. They then ranked them according to their superiority and suitability for tea brewing. They were precise and exacting in their skill: the judgment and discrimination of water quality.

Ancient Chinese classified water based on the apparent source: either from the sky or earth. Waters from the sky were called "heaven's spring." Sky waters included rain, snow, hail, frost, and dew. Earth waters included spring, river, and well water. Li Shi Zhen in *Outline Treatise of Materia Medica* listed 13 types of sky waters and 30 types of earth waters while explaining their medicinal uses. Some were taken internally, while others were applied externally for a variety of ailments. However, most of these types of water are totally unsuitable for tea use. For example, he lists Roof Leak Water, warning of its poisonous nature, which cannot be drunk. He advocates use of Pig Trough Water as a remedy for snakebite wounds. There is Three Households' Dishwashing Water to which salt is added as a treatment for ulcerous wounds. Li Shi Zhen also prescribes a small bowl of City Gates Urine Pit Water as a remedy to eliminate thirst, to which he thoughtfully advises, "don't let anyone know." After just three courses thirst is miraculously dispelled!

Of all the waters listed in *Outline Treatise of Materia Medica*, the following are noted for their connection with tea:

Sky Waters:

1. Rain Water. Plum Rains moisten clothing and cause them to become blackened. During this period everything becomes decayed and black. Plum rains are also

called Mold rains. After Grain in Ear (*Mang Zhong*—on June 5/6/7) is the start of Plum Rains; after Slight Heat (*Xiao Shu*—on July 6/7/8) is the end of Plum Rains.

2. Dew Water. Dew is the liquid of yin *qi*.

3. Sweet Dew, also called glossy dew, auspicious dew, heavenly wine, divine liquid. It is sweet like syrup.

4. Sweet Nectar is autumn dew collected and sweet in taste like honey.

5. Winter Frost. In collecting frost, use a chicken feather to brush it into a bottle. Cover tightly and store in a cool, dark place. Even if stored long it won't go bad.

6. End of Lunar Year Snow is the snow water of *Da Han* or Severe Cold (Jan. 20/21). It has medicinal value in brewing tea; it can cure fever and prevent thirst.

7. Hail. Hail is the mutual struggle between the *qi* of yin and yang. The concentrated *qi* of Yang is hail. The concentrated *qi* of yin is sleet.

Earth Waters:

1. River Water used in brewing tea, gives tea a different taste.

2. Well Water, freshly drawn is best. Wells farthest from deep subterranean sources are superior, those near rivers and lakes where the water can permeate is inferior. Wells in cities near irrigation canals have water that can seep into them, creating alkali water. When using this water, you must boil it vigorously, stop for a moment and only after the alkali settles can it then be used; otherwise, the odor and taste is vile. It cannot be used for tea.

3. Sweet Springs are so called because the spring has the taste of light wine.

4. Jade Well Water is water from mountain springs or wells in valleys where jade is found.

5. Stalactite Cave Water is from springs flowing from stalactite caves. The water is thick and heavier than other waters.

6. Mountain Cliff Spring Water. Springs issue from the earth and rock in the mountain cliffs; their flow is the source of mountain rivers. Those from mountains where there is black earth, poisonous stones, or vile plants cannot be used.

7. Uncooked Cooked Water is also called "yin yang water." Add freshly drawn water to boiling water and allow them to harmoniously mix together. (Note the idea of yin yang water is similar to that of augmenting a portion of cold water to hot water for brewing green tea.)

8. Many waters have poison. After drinking wine, immediately drinking tea water (tea infusion) may make one become an alcohol addict.[1]

TANG DYNASTY

Springs as Outlined in the *Classic of Tea*

Lu Yu in the *Classic of Tea* writes of water sources for tea:

Of waters, use of mountain water is superior, river water is average, well water is inferior. Chuan Fu says: "water where it pours from a river's source scoop up that of the clearest and purest flow." Of mountain water, choose stalactite springs or those of slow flowing stone ponds, which are superior. Do not drink water from cascading springs, gushing springs and geysers, rushing turbulent waters, or gargling, eddying currents—if drunk long it causes people to have throat pain.

And many other water sources flow from mountains and valleys, though they are clear and gradual flowing, they do not flow freely. From the heat of summer to before the start of first frost, there are probably hidden dragons (worms and snakes) and plant material immersed in the water creating poisons during this period. Drinking it, one must irrigate the water first to pour off the vileness. Let new spring water trickle sluggishly into the pond, then pour the water to use. Of river water, fetch it from places far from people, and with well water draw much of it before use.

ZHANG YOU XIN'S *CHRONICLE ON WATER FOR BREWING TEA*

In *Chronicle on Water for Brewing Tea*, Zhang You Xin, through numerous excursions, lists and ranks various waters based on taste and suitability for tea. He attributes the rankings to various individuals, including Lu Yu himself. He claims:

The former assistant minister of the Ministry of Punishments, Liu Bo Chu, with the elder You Xin, once went on a journey. Of profound and extensive knowledge, he (Bo Chu) has a very good demeanor and appreciation (for tea). In comparing water and its suitability for making tea, he classed them all in seven grades:
The Yangzi's Nan Ling water is first[2]
Wuxi Hui Mountain Temple's stone spring water is second[3]
Suzhou Tiger Hill Temple's stone spring water is third[4]

Danyang County's Guanyin Temple water is fourth[5]
Yangzhou's Da Ming Temple water is fifth[6]
Wu's Song River water is sixth[7]
Huai (river) water is last, it is seventh.[8]

These seven waters, I possessed in bottles in the boat, all of which I personally scooped up and compared, so my explanation is sincere. Those people of former dynasties had been familiar with the springs of the two Zhes, [9] that is to say, their search and inquiry was not exhaustive. I already recorded it. Upon inquiring about the water in Yongjia, [10] one passes the Tonglu River, [11] arriving at the swift currents at Yanzi[12], the mountain river's color is clear, and the water's taste, cold. When groups of households used an aged black, or spoiled tea and sprinkled water on it to boil they all became fragrant. Then again, when used in brewing fine tea, the fragrance is indescribable. Further, it is even more remote than Yangzi's Nan Ling waters. Arriving at Yongjia, fetching Immortal Cliff's[13] waterfall (water) to use in brewing tea, it also is not inferior to that of Nan Ling. For this reason the explanations of those knowledgeable of water in former dynasties is indeed believable! Showing reason in examining things, today's people do not believe in the ancients, but also there is much the ancients did not know, though today people can know it.

In the spring of the 9th year of the Yuanhe era (814 CE), the same year as my birthday (Year of the Horse), I just gained a name of great repute at Jian Fu Temple[14]. Li De Chui and I arrived beforehand, taking rest in the west wing of the Xuan Jian Room. Just by chance, a monk from Chu[15] arrived and there were

numerous books placed in his bag. By chance I pulled out a whole book and began reading it. The writing was fine and delicate and inside it contained miscellaneous records. At the end of the scroll there was one title reading "Record of Brewing Tea;" stating that from the Imperial Court of Dai Zong, the prefectural governor of Huzhou, Li Ji Qing, upon arrival in Weiyang[16] happened to meet the scholar-recluse Lu Hong Jian. Li was originally familiar with the name of Lu; and had the pleasure of meeting him for the first time; because of this, he went to the prefecture to meet Lu. Anchoring at a courier station along the Yangzi River, they took their meal. Li said: "Master Lu you are an expert in tea, because of this, the entire world has heard of your name! Moreover, the Yangzi's Nan Ling waters are outstanding. Today we have two wonders: (a skillful tea expert and superb water), this is a rare opportunity; how extraordinary!" He ordered his cautious and trustworthy soldiers to take a bottle and enter a boat to attain Nan Ling's waters in the deepest part (of the river). Lu then prepared utensils awaiting the water. In just a short moment, the water arrived; Lu took a spoon and raising the water, said: "River, ah, river! This is not Nan Ling's water. It looks like water drawn near the shore." Minister Li said: "This boat went deep into the river, and the throngs of onlookers present are numerous, you dare to fool us in vain?" Lu was still unbelieving; he subsequently poured all the water into a pot. At the half way point, Lu abruptly stopped; again taking his spoon and raising it saying: "From here on is Nan Ling water!" The Minister fell, greatly astonished. The servant confessed: "This is from Nan Ling presented in both hands to shore. On the way back the boat swayed, pouring out half the water. Fearing there was too little, I ladled some shore water to increase it. The reclusive scholar's examination is a wise ob-

servation; who else would dare conceal such an error!" Li and his guests, among the dozens of people participating, were all greatly astounded. Because of this, Li asked of Lu: "Since it is so, of all places where you have experienced the water, may you judge for us the superior and inferior choices!" Lu said: "Chu waters are first, Jin[17] waters are last." Li, on the basis of this, ordered a brush, and recorded as dictated by Lu Yu the order of springs:

Lu Mountain's[18] Kang Wang Valley water curtain water (cascading falls) is first.

Wuxi County's[19] Hui Mountain Temple stone spring water is second.

Qizhou's[20] Orchid Mountain River below the stones water is third.

Xiazhou[21] below Fan Mountain has stone suddenly draining water singly pure and clear, the form is turtle shaped; commonly called Frog Spit, it is fourth.

Suzhou's[22] Tiger Hill Temple stone spring water is fifth.

Lu Mountain below Zhao Xian Temple is found Bridge Pool water, it is sixth.

Yangzi River's Nan Ling water is seventh.

Hongzhou's[23] West Mountain East and West Waterfall water is eighth.

Tangzhou's[24] Cypress County Huai River water's source ninth. [Huai river water is also excellent.]

Luzhou's[25] Dragon Pond Mountain Summit water is tenth.

Danyang County's[26] Guanyin Temple water is eleventh.

Yangzhou's[27] Da Ming Temple water is twelfth.

Han River at Jinzhou[28], the Zhong Ling water of the upper reaches (of the river) is thirteenth. The water is bitter.

Guizhou[29] below Jade Void Cavern, Fragrant Mountain River water is fourteenth.

Shangzhou's[30] Wu Guan West Luo River water is fifteenth; it is never muddy.

Wu's[31] Song River water is sixteenth.

Tiantai Mountain's[32] southwest peak Tall Waterfall water is seventeenth.

Chenzhou's[33] Round Spring is eighteenth.

Tonglu[34] (River's) Yanling Beach water is nineteenth.

Snow water is twentieth; in using snow water it shouldn't be too cold.

I sampled all of these twenty waters, but not with fine or coarse tea, beyond this, I don't know how they would compare when brewed with tea. Tea brewing at the place where it is manufactured is refined because they are of the same water and earth, making them well suited to each other. When leaving the place where the tea grows, the effect of water diminishes by half. However, this can be improved by brewing with clean utensils. All good tea making depends on one's skill. Li sets aside various bamboo boxes of tea utensils, and on the occasion where there are those who happen to speak of tea, he would promptly show his collection. You Xin making enquiries in Jiu Jiang[35], had his guest, Li Pang and his disciple Liu Lu Feng, discussing their tea experiences and what they had seen and heard regarding tea.

When I awaken, I long for the previous years at the monk's hall where I got this book, because all my books are in my chest, the book is here. The ancients say: "When rapidly flowing water pours out of the bottle, how can one distinguish the Zi River from the Sheng River?"[36] This saying one surely cannot judge. Such was the ability of the ancients and of this there can be no doubt! How can one know the principle behind the entire world? One cannot speak to this. The an-

cients studied astutely and they possessed an inherent never exhausted quality. Those who are studious and of noble character were diligent and hardworking, not merely educated by their mothers' teachings only! These words also have the benefit of giving advice and encouragement, therefore they are recorded here.

SONG

Emperor Song Hui Zong Zhao Ji's Treatise on Water

Water

Water with clear, light, sweet, clean properties is ideal. Light and sweet are water's nature—these are especially hard to acquire. When ancients tasted and evaluated water, they originally said the Zhong Ling and Hui Mountain waters were superior. However, people are separated by distance from suitable water sources. Whether distant or close, it seems out of the ordinary to acquire any excellent spring water. Still, when fetching mountain spring water, it should be pure and clean. Well water that is frequently drawn can be used, but it is inferior in taste. If river water is used, then it has the rank odor of fish and turtles. Muddy stagnant water, although light and sweet, is not worth using. Generally you can use hot water of fish eyes, crab eyes, or successively drawn silk spurting and jumping as the upper (temperature) limit (for green tea). If the water passes to old water, then put in a small amount of fresh water, fire it for a short time and use it afterwards.

MING

Lu Shu Sheng's Discourse on Water

Seven Categories of Boiled Tea

2. Tasting Springs

In evaluating springs, mountain water is superior. Inferior is river water. Well water is inferior to river water. In wells where much water is drawn, and often drawn, then the water will be moving (circulating and fresh). [37] However, it must be immediately drawn and immediately boiled. If it is drawn and then stored overnight, the taste will have reduced its freshness and clarity.

Zhang Yuan's Judging Springs and Storing Water

Evaluating Springs

Tea is the Essence of water; water is the Substance of tea. If it is not pure and natural water, the Essence cannot be manifested; if it is not exquisite tea, how can one perceive the Substance? Springs from the mountaintops are pure, clear and light. Springs at the mountain bottoms are pure, clear and heavy. Stony springs are pure, clear and sweet. Sandy springs are pure, clear and cold; Earthy springs are tasteless and plain. Flowing from yellow stone is the finest. Flowing rapidly out of green rock is useless. Circulating water outrivals the calm and undisturbed. Water bearing much Yin (waters in damp, shaded areas where the water is cool) surpasses that of Yang (waters in open, sunny areas where the water is warm).

The true source has no extraneous taste, pure water has no peculiar fragrance.

Well Water is Unsuited to Tea

The *Classic of Tea* says: "Mountain water is superior, river water is inferior, well water is the lowest quality!" But on the other hand, when not near rivers or when mountain precipices have no spring water, there are still adequate and plentiful accumulations of "plum rains." [38] Its flavor is sweet and mild, thus it is the water that grows and nourishes Ten Thousand Things. Snow water, although pure and clear, its nature feels heavy with Yin, coldness then enters the spleen and stomach, and it is unsuitable to store much of it.

Water Storage

Store water in an earthenware jar, but one must place it in a dark courtyard. Cover with open-weave silk to cause it to receive the *qi* of starry dew, then its spirit will not dissipate, and its vitality will always be retained. If you cover with wood and stone, seal with paper covering, expose under sun, then externally it consumes its vitality, internally it restrains its *qi*, the water's essence then becomes ruined! Tea drinking only values fresh leaves and favorable water. When tea loses its freshness or water loses its benefit then what difference is the tea when compared with ditch water?

Luo Lin's Explanation on Water

Water

When the ancients evaluated different water sources, not only when brewing tea was it necessary, but they also used it first in making *Tuan Bing* (a green tea cake.)[39] Even though ancient people surely did not traverse the whole world, they tried their best to taste and experience all the waters, tasting and evaluating them successively, but according to those waters that were only commonly known. Sweet springs by chance, stem from remote regions where the native inhabitants rely on them to water their cattle and wash utensils—who can discern and recognize their value? If I pass through those places, then sweet springs frequently exist, like the river to the rear of Peng Lai Hall. There are also refined wells[40] sparkling, sweet and thick, but they are not necessary to brewing tea, certainly one can drink this water as is. Sweet water is not hard to find, but is difficult to find mellow water. Similarly, delicately fragrant and perfectly crystal-clear wine is not hard to find, but is difficult to find light. Mellow water and light wine is not easy to reconcile. If I secluded myself in the midst of mountains and springs, only pairing the water from Tiger Run Spring with that of Sweet Dew Spring to make tea, and then compare the tea using the water of Hui Spring, they would unavoidably be very unlike. Generally, of the famous springs, many enter and issue from rock. Those waters that are obtained from stalactite springs are often of the finest water. Sandy pools are inferior. Of those issuing from much clay many are useless. When Song people fetched well water, they didn't know if the well water merely suited cooking and for making thick soup. When brewing

delicate *ming* tea it definitely was far from ideal. However, only mountain wells are suitable.

For boiling tender *ming* tea, one must use mountain spring water, while use of plum water is inferior. Plum Rains are like cream in that all things depend on it to nourish and grow and its flavor is uniquely sweet. Chou Chi Notes says: The time of rains is sweet and smooth. When pouring tea or boiling medicine, use of Plum Rain is desirable and beneficial. After the Plum Rains, rainwater becomes inferior and when thunderstorms arrive, rainwater is the most poisonous, causing one to be sick with gastrointestinal disease leading to vomiting and diarrhea. Autumn rains and winter rains can totally harm people. Snow water is especially unsuitable, causing muscles to weaken.[41]

Much Plum Rain water should be put into a vessel, taken to a secluded courtyard and put into a large earthenware jar. Then put in two pieces of *Fu Long Gan*[42] and hide it away for more than a month, then afterward draw some water out to use it. This is extremely beneficial to people. [*Fu Long Gan* is the dry earth in the middle of a stove.]

At the base of Wulin's[43] south peak there are three springs: Tiger Run has the best water, Sweet Dew is second to it, Pearl Spring can be considered inferior, and the water of Dragon Well is only comparable to that of Tiger Run. Wulin local, Xu Ran Ming in evaluating water does not speak of Sweet Dew. Why? Sweet Dew Temple is to the left of Tiger Run Spring; this spring resides at the temple's rear corner. The mountain path is very secluded so visitors seldom reach it. How can it be that Ran Ming had not yet visited that place?

Waters of the Yellow River[44] flow gushing from soaring heights in the north-

west and onward to the east. [45] Its tributaries congregate and in what place does it not have any docks? Having no famous springs nearby, one merely draws up some river water to use. It's said its source comes from the Heavens, it does not diminish Hui Spring [this is not the final word on this subject]. In Kai Yuan Anecdotes, there is a story about the idle person, Wang Xiu, who during every winter time, goes to get ice and after striking out only the most sparkling and perfectly crystal clear ice uses it to brew Jian tea (the finest tea in Song times) to respectfully offer guests; this is also too much work.

Zhu Quan's Discourse on Judging Water

Evaluating Water

Qu Xian says: Qing Cheng Mountain's Old Man Village Willow Spring water is number one. Zhong Mountain's Eight Merits and Virtues[46] is second. Hong Cliff's Vermillion Pond Water is third. Bamboo Root Spring Water is fourth. Or it is observed: Mountain water is superior, river water is lower, well water is inferior. Bo Chu regards Yangzi river water as first, Hui Mountain Stone Spring water as second, Tiger Hill Stone Spring as third, Dan Yang Well as fourth, Da Ming Well as fifth, Song river as sixth, Huai river as seventh.

It is also remarked: Lu Mountain's Kang Wang Cavern curtain water is first, Changzhou's Wu Xi Hui Mountain Stone Spring is second, Qizhou's Orchid River below the stones water is third, Xiazhou's Fan (Mountain) in the Gorge Below has Stone Hole dispersing water, it is fourth. In Suzhou below Hu Qiu (Tiger Hill) Mountain, the water is fifth. Lu Mountain's Stone Bridge Pond water is sixth.

Yangzi River's Zhong Ling Water is seventh. Hongzhou's West Mountain Waterfall is eighth. Tangzhou's Cypress Mountain Huai River water source is ninth. Lu Mountain Peak's Heaven and Earth water is tenth. Runzhou's Dan Yang Well is eleventh. Yangzhou's Da Ming Well is twelfth. The Han River at Jinzhou upper flow of Zhong Ling Water is thirteenth. Guizhou's Jade Void Cavern Fragrant Mountain River is fourteenth. In Shangzhou, the Wuguan West Gorge water is fifteenth. Suzhou's Wusong River is sixteenth. Tiantai Mountain's Southwest Peak Waterfall is seventeenth. Chenzhou's Round Spring is eighteenth. Yanzhou's Tonglu River Yanling Beach water is nineteenth. Snow water is twentieth.

Xu Ci Xu's Writings on Choosing Water, Storing Water, and Drawing Water

Choosing Water

Exquisite *ming* tea contains a wondrous fragrance, relying on water to emit its essence. Without water there can be no discussion of tea. When the ancients tasted and evaluated water, Gold Mountain's Zhong Ling spring water was the Number One Spring.[47] Number Two Spring someone said, was Lu Mountain Kang Wang Valley water. [Lu Mountain is now considered the Number One Spring, but I have not gone there.] On the top of Gold Mountain there is a well, but I fear it is not the ancient spring of Zhong Ling. Mountains and valleys change and then become neglected and forgotten. Otherwise, how is it that their light spring waters cannot be ladled out? In present times, upon tasting and evaluating water, necessarily first is Hui Spring; it is sweet, tasty and rich resulting in sufficient worth. Pro-

ceeding over three crossings of the Yellow River, one starts worrying about its turbidity. The boatman has a method to settle the particles by passing the water through a filter. Drinking this water is sweet and especially suited to brewing tea; it is not less than the quality of Hui Spring. The waters of the Yellow River come from the heavens above. When muddy and turbid it has an earth color. When settled it is already clean and the aroma emits spontaneously. I often hear told that famous mountains have fine tea, and now it is also said famous mountains must have fine springs. When raising the topic of both of these subjects, I'm afraid this is a subjective and groundless assumption. Of all the places I have passed through, the two Zhes, the Two Capitals, Qi and Lu, Chu and Yue, Yu-zhang, Dian, Qian, I tasted all of their waters, gradually visiting their mountain springs.[48] The flavor of their spring current originates from afar and of those with very clear and transparent pools, the water is necessarily nice and sweet. Then the water of rivers and mountain rivers where they meet clear deep pools and large ponds, the flavor of these is salty sweet and cold.[49] Only in large waves and rushing currents, flying waterfall springs, or areas where there are many boats then the flavor becomes bitter, turbid and unbearable. These types of water are said to be injurious to your efforts in brewing tea, let alone your perseverance. Spring and summer waters are long lasting then become diminished, then when autumn and winter waters fall, water sources become replenished again.

Storing Water

When Sweet Spring waters are used soon after they are drawn there is a worthy result. Moreover, when taking up residence in the city, how can spring water be

easily attained? The ideal and appropriate way is to draw a large quantity of water, and store it in a large earthenware jar. Prohibited is the use of new utensils, because the fire smell has not receded from them. When this is the case, it is easy to ruin the water, and easy for bugs to grow. Utensils that have been used for a long time are perfect; most detested are utensils used for other purposes. The nature of water avoids the use of wood, especially pines and firs. Storing water in a wooden barrel greatly harms the water content, while use of a porcelain bottle when drawing water is an excellent choice. The mouth of the water storage jar should use a thick covering of bamboo, fixed with clay to make it strong. When it comes time to use it, upon opening, the spring water does not change. Plum Rain water can be a substitute.

Ladling Water

One must use a porcelain bowl when ladling water. Gently take it out of the earthen jar and slowly decant into a kettle. Do not let other water or rain drip into the earthen jar, resulting in ruin to the water's taste; all of this one must remember.

QING

Chen Jian's Amendments on Water

The *Classic of Tea*: "Spring water is superior, rain from the sky is inferior, well water is the lowest quality." Note: Hu Qiu (Tiger Hill) Stone Spring, from Tang

and afterward gradually became plugged, so it cannot be considered superior. And ordinary well water, on the contrary, is well known.

Amendment: Liu Bo Chu in Water Chronicle: When Lu Hong Jian tasted Hu Qiu Sword Pond Stone Spring Water for Li Ji Qing he classified it as third. Zhang You Xin on tasting Sword Pond Stone Spring Water ranked it as fifth. The Yi Men Guang Documents says: "Hu Qiu Stone Spring, old residence, is third; Zhe Jing is fifth. Stone springs that are deep, wide and pure are all rain pools accumulated by seepage; these are hole ponds. Moreover, there are closed huts and graves in tunnels, where formerly many stonemasons were enclosed to die. As the monks and nuns settled there these springs could not be without the filth and impure oozing in. Although it is called Lu Yu Spring, it is not natural water. Daoists take it to drink as medicine, but this is taboo corpse *qi* water.

In investigating the need to dredge and deepen Sword Pond's water source, one has to dig a small channel to flow into Sparrow Gully, only then is the spring water able to flow and move! Li Xi said: Sword Pond's water does not flow for matters of lament, this is so!

COMMENTS ON WATER FOR TEA

Lu Yu inscribes: mountain water is superior, river water average, well water inferior. In the text, he chooses characters which have the double meaning "above, middle, below," therefore the entire sentence could also be read:

"mountain waters are above, river waters are in the middle, well waters below." Lu Yu's tea scrolls serve as an example of how the ancients viewed and ordered their world: spring waters issue from mountaintops, river waters flow through valleys, and well waters percolate underground. Ancient Chinese lived in harmony with nature and they highly venerated particular water sources—stalactite waters were considered the finest for tea. Indeed, mountain spring waters from stalactite springs or from slow flowing stone pools are excellent choices for tea. In brewing tea, gently flowing water is preferred to rapidly gushing water, such as the swift currents from fast rivers or the crashing cascades of waterfalls. Gushing waters contain much more sediment than gently flowing water, making them a less than ideal choice for tea. However, water sources for tea should not flow sluggishly. As Zhang Yuan advises, circulating water is fresher and therefore better suited to tea than stagnated, sluggish water. Well water, also frowned upon for tea by ancient experts, was due to the salt or alkaline taste of some wells, which mutes tea's delicate flavor and aroma. Tea Master Lu held a very low opinion of inferior well water.

Zhang You Xin compiled a list of water sources; ranking them in order of suitability for tea brewing. He attributes this list to Lu Yu, which seems unlikely. Lu Yu, writing in the *Classic of Tea,* disdained river waters, abhorred waterfall water; yet out of the twenty water sources Zhang You Xin lists as dictated by Lu Yu, according to the *Classic of Tea*, half of these are perhaps unsuitable for tea. That Zhang You Xin was trying to gain wider acceptance of his personal water rankings by associating them with Lu Yu's fame as a tea master seems more believable.

No matter who ranked China's springs first, the mere existence of such a definitive ranking (in what obviously must have taken years of research to complete) is quite admirable. We, as Teaists, are enriched with tea doctrine from such an exhaustive investigation into water for tea.

Zhang You Xin observes that locally grown tea matched to local water tastes best; since the tea trees are watered and nourished by the same water and soil. The theory is that the local water contains similar mineral content to that from which tea trees get their nourishment. This is the same idea as in the common saying: Dragon Well Tea must be brewed with the water of Tiger Run Spring. This same principle, by extension, could also be applied to any tea—Wuyi teas taste best brewed with water from the Wuyi Mountains, for example.

In his text, Zhang You Xin makes comparisons between Tonglu River's Yanzi Beach water, the Yangzi River's Nanling Spring, and Yongjia's Immortal Cliff Waterfall. Tonglu's water when used to prepare even old, stale tea, still produces a wonderful fragrance; when brewed with new tea, the fragrance and taste are beyond compare. However, no waters even remotely surpass the quality of the Yangzi's Nanling spring water—what was unsaid speaks even more about Nanling's superiority for tea. Immortal Cliff Waterfall though not listed in his rankings of twenty water sources, is comparable to the water of Nanling Spring.

Snow water, because it's cold, is not appropriate to immediately use in the winter or use with new spring tea nurtured over the winter by cold winds. Stored until summer and then used, the warm season counteracts the negative effects of so much cold qi. This is why Zhang You Xin cautions that snow water shouldn't be too cold.

Ancient and modern Chinese are keen to avoid intake of food or drink with either heavy Yin or heavy Yang, since it upsets the body's natural balance, causing health problems. They are regarded as either "cold" or "hot"—not as it pertains to temperature but whether it contains "cold" *qi* or "hot" *qi*. When foods are too "hot" or too "cold" one should avoid them, or consume as little as possible because they have an overabundance of either yin or yang; considered harmful for the body and detrimental to one's health. Zhang Yuan, writing in the Ming, also says snow water is "cold," thus containing an overabundance of yin.

In *The Record of Tea*, Zhang Yuan entertains the notion of a metaphysical discussion of water. Tea is the *Shen* (Essence) of water, while water is the *Ti* (Substance) of tea. The *Da Dai Li* says: "The vitality of Yang is called Shen."[50] Shen is the essence of Yang force. Tea leaves, nurtured by sunlight to grow, directly receive Yang essence stored in the leaf. Tea leaves are then indeed the Essence, while water is the body or Substance in which tea can express its Essence. Water is also the yin element, so there is a mutual interaction of yin (water) and yang (tea leaf) to create a harmonious infusion of taste, color, and aroma.

The Essence (*Shen*) and Substance (*Ti*) can also be interpreted as an allusion to a person's vital force and physical body. Without vital force, the body is just an inanimate object; without physical body, there can be no vital force (which keeps the heart beating, the brain functioning, the lungs breathing). The two parts are mutually necessary. This is the point Zhang Yuan makes: exquisite tea and fine spring water are mutually necessary elements—tea's vivaciousness is discerned through water's substance.

Tiger Hill Stone Spring,[51] mentioned by Chen Jian and other tea writers, is located in Suzhou, Jiangsu province in Tiger Hill (Hu Qiu) Mountain.[52] Also known as China Number Three Spring[53] and located next to Sword Pond[54], the spring was created by Lu Yu when investigating the manufacture of tea in Suzhou. As he used Sword Pond's water to prepare tea, Lu Yu personally dug out a hole to create the spring or well. For this reason, Tiger Hill Stone Spring is also known as Lu Yu Spring or Lu Yu Well. At the same time, Lu Yu planted tea in the area, giving rise to a new tea industry there. This spring, still in use today, has over 1,200 years of history. Besides Tiger Hill Stone Spring, other springs in China also bear the honorific name "Lu Yu Spring."

MODERN REFLECTIONS ON WATER

Although the ancients were able to use many special water sources for their tea (rain water, hail, snow, dew, frost, river water for example), today, because of pollution and contamination concerns, most of these water sources are totally unsuitable for tea.

When the ancients drew their water however, they still filtered it; Lu Yu himself lists a mesh water filter as an important tea utensil. Today, we have the convenience of tap water, but it must still be filtered for tea to remove chlorine and improve the taste.

Not all mountain water sources as observed by the ancients are suitable for tea. Mineral content, the relative amounts of dissolved minerals and types

of minerals present, all vary from source to source, location to location. Both dissolved mineral content and pH of spring water affect the taste of the water and ultimately the taste of a steeped infusion. Ancient Chinese also recognized the importance of mineral content and its effect on tea flavor, which is why Lu Yu declares stalactite springs are the finest. Taste, not precise mineral content or pH, should be the exclusive deciding factor when preparing your tea. Of course, the rare origins of your special water source can give your tea a fanciful appeal and an exotic flavor.

The five special attributes of spring water ideal for tea, according to Song Emperor Zhao Ji are clear, light, sweet, and clean. Clear meant the water was uncolored or unclouded by sediment, minerals, or plant material. Water clarity was important since it directly affects tea infusion color. Light meant light in weight, which is an indicator of water hardness. Qing Emperor Qian Long, a noted tea enthusiast, on his personal excursions about the Middle Kingdom, reputedly weighed water samples using a finely crafted silver scale, ranking spring waters based on their lightness. The lightest waters (and therefore, specimens of the least hard water, or lowest mineral content) were considered the most exquisite samples for tea brewing. Beijing's water sources are relatively alkaline, which is why Qian Long sought the lightest sources. Because of the alkaline content, scented tea became the favored tea of Beijing since this tea, when brewed with local water, still retained its taste and fragrance. Sweet meant the taste of the water had to be sweet, not bitter. Cai Xiang in *Record of Tea* asserts: "if a mountain spring is not sweet, it can spoil tea flavor."[55] Bitter tasting water on the other hand, accentuates the bitterness in the steeped infu-

sion; likewise, peculiar tasting or smelling water mutes, masks, or subdues the delicate scents and flavors in the steeped tea. Through a taste comparison of water samples, one could determine each water source's relative sweetness. Tea is naturally bitter. By pairing sweet water with bitter tea, some of the bitter edge is removed, improving the overall taste of the tea. Clean meant the water source was free from pollutants or contaminants. Water for tea must be clean to prevent drinkers from becoming ill, but just as vital, so as not to taint or mute the natural, delicate taste of the tea.

Fresh, flowing water is also essential. If the water is flowing or moving then it stays oxygenated. Flowing water will then be fresh, not stagnant, providing a superior taste and improving tea infusion flavor. Any water, no matter the source, must be moving to stay oxygenated—well water often drawn is best; flowing water is superior to stagnant water. Water that does not flow or loses oxygen tastes flat, imparting a flat taste to steeped tea.

Choice of water for tea use, based on taste and affinity for tea, is crucial; water is the substance of tea and helps to best express the tea's essence. For this reason, the ancients, in exacting and precise measure, evaluated and ranked water sources most suitable for tea use.

What would ancient tea masters think of all the bottled water we now drink? It is certainly not fresh, moving water. Perhaps, phrasing it in Zhang Yuan's words, the *qi* of bottled water is internally restrained, thus the essence of the water ruined. Truly, there is art in choosing and evaluating water sources for tea.

許次紓茶疏　火候

火必以堅木炭為上然木性
未盡尚有餘煙煙氣入湯湯
必無用故先燒令紅乃易煙
焰薰取性力猛熾水乃易沸
既紅之後乃投水器仍急扇
之愈速愈妙毋令停手停過
之湯寧棄而再烹

庚寅年亥月張熙陸書

CHAPTER THREE

Preparing Fire for Tea

HEATING THE FIRE

In order to boil water for tea use, fire first had to be exactingly prepared. There was a very skilled technique to heating the fire[1] in ancient times. Not only did one need all the proper equipment for laying and tending a fire (charcoal stove, stove stand, chopsticks, fan, wood charcoal, charcoal box), but also one had to know how to tend the fire, fan the fire, create the proper amount of heat, reduce the amount of smoke to a minimum. Therefore, even before one could boil the water or steep the tea, one first had to learn to prepare the fire, then learn to boil water, then learn to steep tea. If one did not employ the correct technique in preparing fire, then all subsequent efforts would ultimately fail. Although today we use electric stoves to heat our water, we can gain an appreciation for the amount of time and effort the ancients put into their tea making—their tea preparation was toilsome and exacting.

TANG

Lu Yu's Discourse on Fire

Of fire, use charcoal; inferiorly, use sturdy firewood (these are called varieties of mulberry, pagoda tree, and oak.) Of charcoal, do not use those that were once roasted, odorous and greasy (such as that used for cooking); oily woods (containing pitch); and failed utensils. (Oily woods are cypress, pine, and juniper. Failed utensils are rotten or worn-out useless wooden utensils.) The ancients had the odor of toiled firewood.[2] This is believable!

MING

Tian Yi Heng's Discourse on Fire

Having water, having tea, one cannot do without fire. Different fires, like flameless fires, also have their own suitability. Li Yao says: "Tea requires slow fire to roast and moving fire to boil. Moving fire is so-called charcoal fire that has a flame."[3] Su Shi's poem "moving fire yet requires moving water to boil" is true, too. I believe, in the mountains, one cannot often obtain charcoal. Moreover, there is only dead fire and though not as good, the use of dead pine branches is fine. If, on a cold moonlit night, you can pick up many pinecones to collect as tea boiling material this is even more refined.

People merely know hot water but they don't know about heating the fire. When the fire burns then the water dries up. One must first test the fire and only then try the water. In Master Lu's Spring and Autumn Annals, Minister Yi, when speaking of the five flavors (salty, bitter, sour, piquant, sweet) of hot water (broth), says there are nine boils, and nine changes. Fire is the regulator of these.

When the water is merely simmered, then the tea flavor cannot be expressed. When it is past boiling, then the water is old and the tea is lacking. The tea infusion then only has flowers and no clothing (has fragrant scent but off-taste). In this way, one can learn about the degree of pouring and brewing only.

Tang people took tasting floral tea as "killing the scenery"[4] (extremely overdone). Therefore, Wang Jie Fu's poem says: "In Gold Valley, a thousand flowers there is none who put to casually boil."[5] The meaning is in the flowers, not in the tea. I therefore believe Gold Valley's flowers in the former message are unsuitable! If you take a bowl of tea and facing toward the mountain flowers drink it, this aids even more the enjoyment of the scenery, further, then what is the need for Gao Er wine?[6]

Boiling tea must be done appropriately, yet drinking is incorrect for people. Just as drawing water from a stalactite spring to irrigate weeds is an offense of the greatest, a tea drinker who with one suck finishes drinking while having no time to distinguish flavor—there is none who is more vulgar.

Xu Ci Shu's Discourse on Fire

Heating the Fire

The fire must use hardwood charcoal, which is regarded as the best material, then the wood nature is unexhausted. When there is too much smoke, then the smoke will enter the boiling water, the boiled water then necessarily becomes useless. Therefore, first burn the charcoal to red to rid it of smoke and flame. At the same time, get a strong, vigorous burning fire. The water then easily boils. After the charcoal is already red, then place the water kettle over it. At the same time rapidly fan the stove—the quicker the better; do not stop your hand. Hot water that had stopped boiling is preferably discarded and fresh water boiled again.

Zhang Yuan's Discourse on Fire

Heating the Fire

Of the essential points in tea brewing, the first is heating the fire. The stove's fire must become red, then the teakettle may be placed atop. When fanning, it must be light and fast; wait until there is a sound, then gradually fan harder and faster. These are the states of Gentle Fire and Fierce Fire.[7] When the fire passes to Gentle Fire, then the water will have soft characteristics. If the water is soft (simmered), the tea quality will fall. When the fire passes to Fierce Fire, then the fire will have intense characteristics. If the fire is fierce, then the tea will prevail by the water. If all is insufficient to properly obtain a harmonious infusion, this is not a tea specialist's main objective.

COMMENTS ON FIRE

Lu Yu advised that charcoal is best for a fire, since it won't give off smoke. Less desirable is hardwood firewood like mulberry, pagoda tree, and oak. When burned, however, these types of wood produce many long-burning embers that are ideal for heating water. However, charcoal used in roasting meats or any other odorous or greasy foods is strictly not to be used. Equally unsuitable are resinous woods such as cypress, pine and juniper trees, which are prone to sparking. Also, rotten utensils emit such a strong odor when burned it makes them undesirable for tea making.

The choice of firewood really is crucial in tea preparation. In North America, oak, elm, and ironwood burn hotter than other woods and produce many coals suitable for a tea stove. Indeed, in a wood-burning stove, if too many logs of this kind of firewood are added, the fire may burn with such intensity and fierceness it may end up cracking and completely ruining a cast-iron stove. On the other hand, some hardwoods, like poplar, burn up almost completely, producing little or no coals. Interestingly, in maple syrup season, poplar firewood is also not favored since it imparts a bitter taste into the boiling sap. While some trees, like black poplar or black ash, emit a very pungent, unpleasant odor when burned, so are equally unsuitable as firewood, especially for tea.

Fuels for tea included charcoal, hardwood firewood, dead pine branches, pinecones, but the best fuel is charcoal. Smoke is the enemy of tea. Ensure the fire for tea is well lit and free of smoke. Where no charcoal can be obtaincd, particular attention should be paid to ensure that the tea fire does not become

a dead fire; such as when green, wet wood is used producing a smoldering, smoky fire with little heat or flame. A proper tea fire should be a "moving fire," that is, one with flame. Moreover, fire for boiling water should be a Fierce Fire as opposed to Gentle Fire: the fire should be hot and strong burning; not slow-burning and cool. Continual and quick fanning helps create a Fierce Fire; yet the fanning should be light enough so as not to disturb the coals in the tea stove.

Tian Yi Heng recognized the importance of fire in regulating the speed at which water boils. He quotes from *Master Lu's Spring and Autumn Annals* under the chapter, "The Root of Flavor", which is a philosophical discussion of cooking. Particularly boiling various meats and fish in water: to skim the fat and remove rank or musky smells from the meat and then to season the broth with five different seasonings. The degree of fire was important in order to boil the water to the correct temperature and give it the length of time to clarify the broth and to properly develop the flavor. Minister Yi remarks: "At the root of all flavors, water is the very start. There are Five Flavors (bitter, salty, sweet, piquant, sour) and Three Materials (water, wood, fire); Nine Boils and Nine Changes. Fire is the regulator of these." Applied to tea, a properly regulated fire develops the heated water; hot water then allows tea essence to fully bloom. When the fire is too hot, the water seethes, scalding delicate tea leaves. When the fire is too cool, the water simmers, creating underdeveloped tea flavor.

In ancient times, much work and attention was paid to the tea fire. Although today we no longer need to make a fire to boil our water for tea, we may greatly admire the skill ancients possessed in all aspects of tea preparation. Today, in

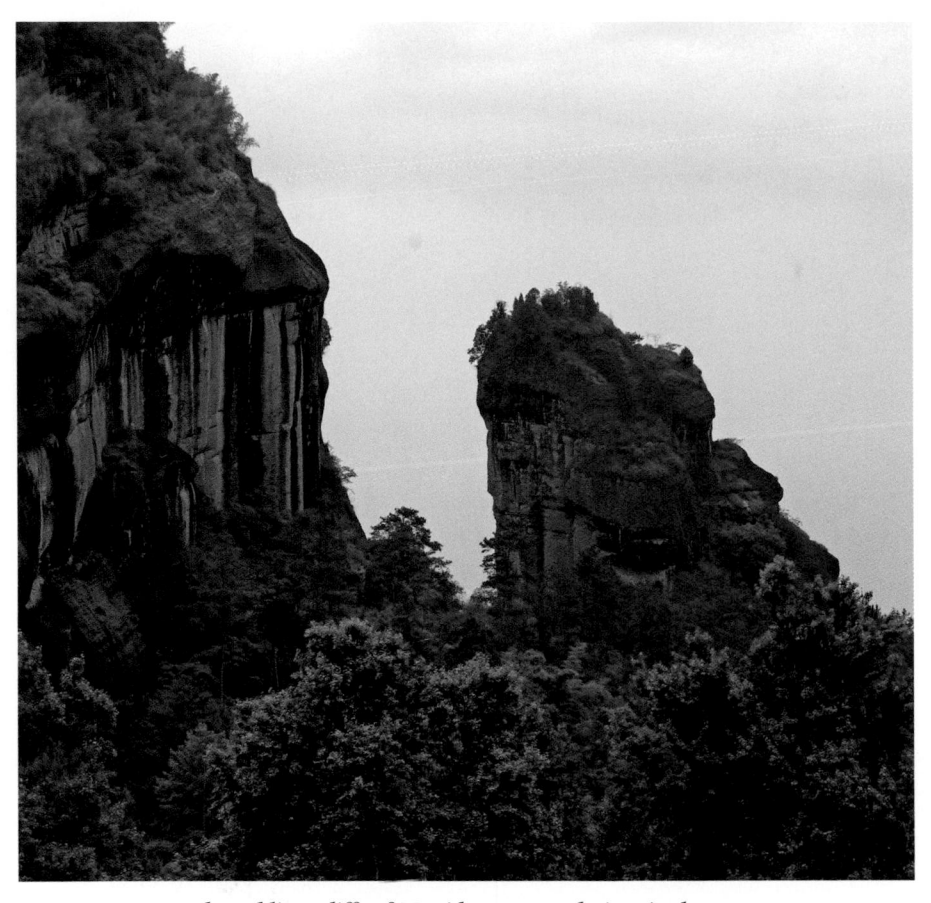

The sublime cliffs of Wuyi have not only inspired poets but also produced the world's most exquisite teas.

注雲腳渾開乳
花浮面則味全
蓋古茶用團餅
碾眉味易出葉
茶驟則乏味過
熟則味昏底滯

庚寅年
初夏
張銀法書

From Lu Shu Sheng's Tea Hut Chronicle,
section three: Boiling and Pouring Tea

陸樹聲

茶寮記

三煎點

煎用活火候湯

眼鱗鱗起沫餑

鼓泛投茗器中

初入湯少許俟

湯茗相投即滿

Since ancient times, tender tea buds were the most prized parts of the tea plant.

Roasting tea helps it develop a robust flavor and aroma.

The Imperial Tea Garden, beginning in the Yuan dynasty, once contained the finest tribute teas destined for the Imperial Palace.

*Steeped, loose-leaf tea, popularized 600 years ago,
remains today as our modern method of tea preparation.*

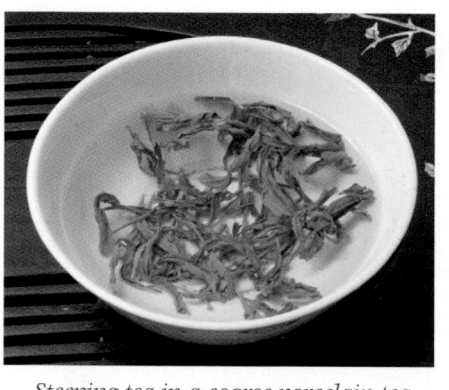

Steeping tea in a coarse porcelain tea bowl is a charming way to drink tea.

Tang tea masters used compressed bricks of steamed green tea.

Four characters for the word tea found in Lu Yu's Classic of Tea: (clockwise) Cha, Ming, Jia, She

This freshly harvested and processed Shuixian tea is an oolong tea that must undergo roasting over a period of several days to develop the full flavor and aroma of the tea.

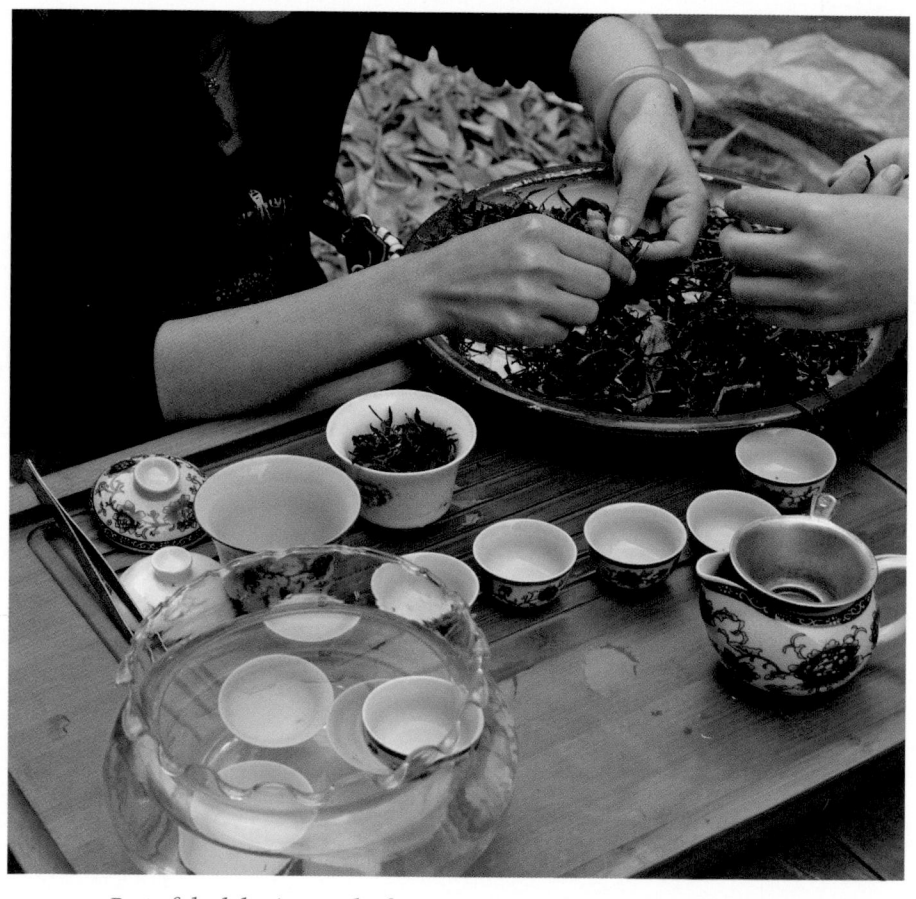

Part of the laborious task of processing tea, stems are hand removed from leaves of maocha (raw tea) as one final step in tea processing.

Bamboo root tea scoops serve the dual purpose of incorporating nature into tea drinking while preventing contamination of the tea.

Creating the proper fire to produce sufficient heat without smoke was considered a great skill in tea preparation; but was also a laborious, time-intensive task.

Steeping time is important: when steeped too abruptly, the flavor and essence does not become fully expressed; when steeped too long, the infusion becomes dark, strong, and bitter.

Spring Feast (detail); Southern Song Dynasty.
(courtesy of The Palace Museum, Beijing)

*Crackleware glazes such as this were popular in the Song Dynasty,
as evidenced by wares from the Ru, Ge, and Longquan kilns.*

When guests come from afar to visit and as host receives guests, isn't it wonderful to be greeted, warmed and comforted by a steaming cup of fragrant tea?

Hui Mountain Tea Banquet by Wen Zheng Ming; Ming Dynasty, 1518.
(courtesy of The Palace Museum, Beijing)

These teacups are a modern revival of the famed Ge kiln ware glaze style. The Ge, Guan, Ding, Ru, and Jun kilns were renowned in the Song Dynasty for their exquisite glazes.

comparison, we have electric induction elements that can boil a kettle of water in 30 seconds. No longer do we need to light a fire, continually fan it, and ensure the water boils completely—how toilsome! However, the water must still boil quickly and it must boil to the proper degree. So it is still important to test and know your kettle and equipment to produce properly boiled water at the right temperature to express the best of the tea essence.

The kettle and type of heat source are still important to evaluate. There are induction type burners, cordless kettles with built-in burners, gas or butane stoves, alcohol burner stoves, and charcoal stoves. Each has its own merits and drawbacks.

HEATING THE WATER

Heating the water[8] was the most crucial step in tea preparation. Teas of the Tang and Song Dynasty typically used powdered green tea, when added to heated water in a pot or when water was poured directly over it in a tea bowl the tea infused immediately. Therefore, achieving the correct water temperature was crucial in order to fully develop the essence of these teas without spoiling the tea by overheating the water. Tea masters of these periods, having no thermometer, used sight and sound to determine the proper water temperature. Fine, delicate, powdered green teas required a very low temperature of heated water—the so-called "crab eye" water. By the Ming Dynasty, whole leaf teas were preferred, but these green teas were also very tender, of extremely small,

delicate spring buds. They too, required relatively low water temperatures for proper steeping. However, unlike powdered tea, these teas required water heated to a higher degree in order for the whole leaves and buds to fully infuse their essence into the water. By the Qing Dynasty, as oolong, and later black teas, came to be developed in China, near to fully boiled water was required to fully steep these types of teas, some of which have much larger, coarser leaves than the tender buds of green tea, and require a longer steeping time in order to produce a tasty infusion. Thus the boiled water of this period, particularly for oolong and black teas required less attention to the degree of boil than in Tang, Song and Ming times—the water was simply heated until it fully boiled. Today, as during the Qing, we still fully boil our water for steeping tea.

TANG DYNASTY

Lu Yu's Description of the "Three Boils"

Of boiling, when the boiling water is like fish eyes, and there is a slight noise, this is the first boil. When on the edges it is like a surging spring and joined pearls, this is the second boil. When the water is surging and swelling waves (rolling boil), this is the third boil. Anything after this, the water is old and cannot be drunk.

SONG DYNASTY

Zhao Ji's Discourse on Boiling Water

Generally you can use hot water of fish eyes, crab eyes, or successively drawn silk spurting and jumping (the joined pearls stage) as the limit. If the water passes to old water, then put in a small amount of fresh water, fire it for a short time and use it afterwards.

Cai Xiang's Discourse on Boiling Water

Heating the Water

Heating the water is the hardest. If the water is under-boiled then the foam floats, but if over-boiled then the tea sinks. What previous generations called "crab eye" water was hot water that had been matured. Furthermore, when boiling hot water in a bottle, one cannot distinguish the degree of boil. Therefore, it is said heating the water is the hardest.

MING DYNASTY

Zhang Yuan's Distinguishing the Boil

Distinguishing the Boil

Hot water has three major differentiations and fifteen lesser differentiations. First there is form differentiation, second there is sound differentiation, third is steam differentiation. Form is an inner differentiation. Sound is an outer differentiation. Steam is rapid differentiation.

There are shrimp eyes, crab eyes, fish eyes, joined pearl; all of these are the start of hot water. To the point where the water is a surging spring, and surging, swelling waves, and the steam has totally disappeared, this is totally boiled water.

There is first sound, rotating sound, rising sound, sudden sound: all of these are the start of hot water. To the point where there is no sound, this is totally boiled water.

There is steam floating as one wisp, two wisps, three or four wisps, and wisps so indiscriminate that they cannot be distinguished and dense steam randomly winding around—all of these are the start of hot water. When it gets to the point where the steam directly soars upward, this is totally boiled water.

Use of Tender or Old Hot Water

Cai Jun Mo's hot water uses tender water[9] and does not use old. This is because when the ancients manufactured tea it must be ground; when it was ground

then it must be milled; when it was milled then it must be sifted. Then the tea becomes soaring dust and flying powder! If there is stamped on the tea, Dragon Phoenix Ball,[10] then you will see the tea infusion and the tea spirit float; this type of tea uses tender water and does not use old water. Today's tea production does not rely on sifting or milling. All have the original leaf form. This infusion must be pure and mature. The original spirit thereupon develops. Therefore it is said hot water must have Five Boils[11], the tea then produces Three Marvels.[12]

Steep Method

When you find the hot water is totally boiled, withdraw it from fire. First pour a small amount of hot water into teapot to dispel cold *qi* by swaying, and afterward pour out, then put in the tea leaves. The tea leaf amount to use should be as suited to drinking, but it cannot pass the appropriate amount thereby losing its true nature. When there is a large amount of tea leaf then the flavor is bitter and the fragrance heavy; when the water exceeds then the color is light and the scent scant. After (brewing) two pots, use cold water to wash again—to cause the teapot to become cool and clean; otherwise, there will be reduced tea fragrance! When the teapot is ripe then tea spirit is unhealthy; when the teapot is clean then the water's characteristics will always be a benefit. Gradually wait for tea and water to become infused together. Afterward, pour portions and spread out to drink. Pouring is not suited too early, drinking is not suited too late; if early then the tea spirit has not yet developed, if late then the wonderful fragrance has first dissipated.

Placing Tea

Placing tea has a procedure; do not underestimate its appropriateness. Placing first the tea and then hot water is called Bottom Placement. Pouring hot water to half way then placing tea and returning to pour full with hot water is called Middle Placement. Pouring first hot water and after putting in tea on top is called Upper Placement. In spring and autumn, use Middle Placement; in summer, use Upper Placement; in winter, use Bottom Placement.

Xu Ci Shu's Description of Utensils and Boiling Water

Utensils for Boiling Water

Metal is water's mother; tin possess soft and hard qualities; its taste is not salty and astringent, made into kettles, tin is the best material. The middle of the kettle must pass through the center of the tea stove to cause penetration of the fire's heat. When water is boiled quickly then it stays fresh, tender, natural, unrestrained. When water is boiled slowly or too long then it becomes old, overdone, murky, dull, combined with much steam: one must be cautious and careful about it. Tea flavor is expressed in water; water relies on utensils; hot water matures from fire. The four are mutually necessary—lacking any one of them then one must abandon their efforts.

Brewing

While having not yet drawn water, first prepare the tea utensils. They must be clean and must be dry. Open the mouth of the teapot so as to receive tea leaves.

The cover is either placed face upward or placed on the porcelain basin—do not go so far as to topple it. Lacquer odor or food odors on the tea tray can all spoil tea. First hold the tea leaves in the hand, as soon as the hot water enters the teapot, immediately put tea into the hot water. Put the cover on securely. After three breaths' time, next empty out (the rinse), filling it into a basin. Again put hot water into the teapot so as to cause rippling fragrance; and so the "fish" (tea leaves) do not stagnate. Repeat another moment of three breaths, in order to make still the floating and thin leaves. Afterward, effuse the tea and offer it to guests, then the liquid is delicate, pure and smooth; and the strong fragrance emits when the cup is held under the nose. Drinking tea when ill may permit one to recover; drinking tea in exhaustion may permit one to invigorate. When having tea at a poetry meeting detached of mundane thoughts, can graceful thought be vented, while taking tea in a hall discussing classics and chatting about art may the profound thought of scholars be cleansed (refreshed, reinvigorated).

Measuring Amount

Teapots are best suited to the small, unsuited to the very large. When a small teapot is used then the fragrance is thick; when a large teapot is used then the fragrance easily disperses. Teapots reaching approximately a half *sheng* (about 480 mL) are considered most appropriate. When pouring tea and drinking tea alone, then the smaller the teapot is the better. For teapots holding half a *sheng*, measure out five parts of tea; this amount may be increased or decreased according to personal taste.

Boiling the Water

When water first enters the kettle, right away it must rapidly be brought to a boil. Depending on the degree of boil there is a pine sound, then remove the lid to get information of the water's oldness or tenderness (over-boiled or under-boiled). After crab eyes become few and the water has slight billows, this is the appropriate moment. Large billows in cauldron boiling, returning to no sound is past the right time. When boiled water is past the ideal time, then the hot water is old (stale) and fragrance dissipated—under no circumstances can it be used.

Huang Long De's Boiled Water

Six on Hot Water

Hot water controls the destiny of tea; therefore, heating the water is the hardest (step in tea preparation).[13] When hot water is immature (under-boiled), then the tea floats to the top—this is called "Baby Water," the fragrance cannot then come forth.[14] When hot water is past mature (over-boiled) then the tea leaves sink to the bottom—this is called "Longevity Water," the flavor then is very stagnant.[15] Properly heated water must employ direct flame with rapid fanning. If the surface of the water is like liquid pearls, and the sound is like soughing pines in the wind, this is exactly the proper type of heated water. What kind of friend is Wu Run Qing, living in seclusion on the shores of the Qin Huai river[16]? He has a suitable temperament for a tea journey[17]—in tasting springs he has the marvel of You Xin, in boiling water he possesses the wonderful skill of Hong Jian—he may be called today's preeminently skilled person.

Luo Lin's Boil

Boil

Famous teas are most appropriately boiled using the water of famous springs. First, let the fire blaze, only then place the water kettle atop, rapidly fan the fire to make the water surge in boiling, then the hot water quickly becomes tender (lightly boiled) and the tea color will also be pale. The *Classic of Tea* says: "like fish eyes and having a slight sound is the first boil; edgeways like a surging spring and joined pearls is the second boil; surging and swelling waves is the third boil; past this point then the hot water is old and cannot be used." Li Nan Jin said: Suitable hot water for tea use occurs between leaving the second boil stage and entering the start of the third boil as the appropriate measure of time.[18] This is truly a connoisseur. And yet Luo Da Jing dreads the hot water passing to old. One need at the point after which the boiling water sounds like soughing pine winds and a valley brook, move the bottle and remove the fire; wait a moment for the boiling to stop and then infuse tea. One may not know whether the hot water is already old (over- boiled)! Even though the water is removed from the fire, how can one fix it? This discussion also has no pertinent information.

Jie tea uses hot boiled water to wash the leaves and is then squeezed dry. Use of boiling water to brew the tea follows according to the thickness of the steam. If the tea is not washed, then the flavor and color become too strong and dark; and the fragrance also does not issue forth. Furthermore, for famous teas, one entirely need not wash them.

Lu Shu Sheng's Boiling and Pouring Tea

Three Boiling and Pouring Tea

In boiling water, use direct flame; in heating the water, eyes (bubbles) and scales (ripples) arise, when there is floating froth on top of the hot water, fan away the foam, then put tender tea into the brewing vessel. When first pouring in hot water, add only a small amount. Wait for the hot water and tea leaves to mutually touch (mix) together, then continue to pour full with hot water. As the cloud froth (from the steeped tea) gradually opens, and when the froth floats on the surface, then the flavor is complete. Because ancient tea used *Tuan Bing*[19] (powdered cake tea), so the flavor of the ground tea powder was easily (quickly) expressed in hot water. Leaf tea, when infused too quickly, the flavor becomes insipid; when infused too long then the flavor becomes dim and mediocre.

Xu Bo's Description of Boiling Water

The ancients boiled tea as poems were copied and written about heating the water; each had exquisite skill. Pi Ri Xiu's poem says: "Now and then see crab eyes splash. I see suddenly fish scales (ripples) arise."[20] Su Zi Zhan's poem says: "When crab eyes already passed fish eyes are born, whishing on the verge of making pine winds sound."[21] Su Zi You's poem says: "When the copper cauldron attains fire, earthworms call."[22] Li Nan Jin's poem says: "Crickets chirping, ten thousand cicadas hurrying."[23] Imagining this scenery, a gentle breeze arises (one attains a state of lightness and elation).

Zhu Quan's Boiling Water Method

Water Boiling Method

Use of charcoal that has flame is called direct fire. In the event the hot water inevitably boils, the first boil is like fish eyes scattering, the middle boil like a spring gushing or joined pearls; the final boil is then surging and swelling waves with steam totally dispersing. These are the three boils method. If the fire is not direct fire with open flame, the water cannot come to a full boil.

Feng Ke Bin's Discourse on Brewing Tea

Discussion on Boiling Tea

First use superior quality spring water to wash the boiling vessel; the kettle should be fresh and it should be clean. Next, with hot water, wash the tea leaves, yet the water cannot be too boiling: if the water is rolling boiled, then with one wash there will be no remaining flavor! With bamboo chopsticks (tongs), pinch the tea leaves into a clean vessel. Repeatedly clean the leaves to rid them of dust, yellow leaves, and coarse stalks cleanly. Use the hands to hold the dry tea leaves; place them into a clean brewing vessel and affix the cover. A moment later, open the cover to see, the leaf color should be light-green, the fragrance intense. Quickly fetch boiled water to sprinkle onto the tea leaves. In summer, first put in the water and only afterwards does the tea go into the teapot; in winter, first put in the tea and only afterwards does the water go into the teapot.

QING DYNASTY

Chen Jian's Amendments on Boiling Water

Five on Boiling

Classic of Tea: Mountain waters and stalactite springs, or water from deep stone ponds overflowing can all be used to boil tea. [Note: When Lu Yu came to Wu, Sword Pond had not plugged; how I long for the sluggish trickle of its flow.[24] Today it cannot be used for brewing tea.] In the degree of boiling water, the commencement is called shrimp eyes; next is called crab eyes; next is called fish eyes. The water boils to the point where one hears as though pine winds sound, and gradually to become no sound. [Note: Shrimp, crab, fish eyes are said to be the internal form of boiling water. When the water sounds like pines soughing in the winds to the sound gradually slowing, then the degree of fire has arrived! Past this point then the water becomes old (over-boiled).] Do not use greasy (pitchy) firewood or exploding charcoal for the tea fire. [Note: Dry charcoal is the most suitable; dry pine tongs (sticks) are especially wonderful.]

Supplement: Su Yi Zhuan: "Hot water controls the destiny of tea; if famous tea is added to excessive hot water; then with ordinary, coarse tea there is no difference. Therefore in boiling hot water there is old (over-boiled) and tender (under-boiled); in pouring, there is slow and fast; not past either extreme are the limits of tea." Lu Ping Quan in *Tea Hut Chronicle:*

"Tea uses direct flame; in heating the water, eyes (bubbles) and scales (rip-

ples) appear, when there is floating froth on top of the hot water, fan away the floating foam; then put tender tea into the brewing vessel. When first putting in hot water, add only a small amount, wait for hot water and tea leaves to mutually touch (mix) together; then continue to pour full with hot water. As the cloud froth (from the infused tea) gradually opens, and as the froth floats on the surface, then the tea's flavor is complete. Because Tang and Song people used *Tuan Bing* which was ground to powder, the flavor was easily (quickly) expressed. Today, we use leaf tea; when infused quickly then the flavor becomes insipid; when infused too long then the flavor becomes dim and mediocre!"

Classic of Tea: Use of utensils includes tea stove, charcoal beater, cauldron, fire tongs, paper bag, basket, filter, gourd ladle, bowl, wash-up cloth.

Supplement: Tin bottle (kettle). Yixing teapot: those of coarse clay finely made are superior. Tea bowls: those of Ge Ware[25,] which are thick and heavy, are the finest. For bottle (kettle) and teapot, use a small straw mat to prevent scorches on the lacquer tea table.

COMMENTS ON BOILING WATER

Lu Yu, writing in the Tang Dynasty describes the degree of boiled water based on the appearance of bubbles in the water: first is fish eyes, second is joined pearls, third is surging and swelling waves; the point where the water continu-

ously boils is considered old water and cannot be used. However, compare this with Zhao Ji's comments in the Song where he recommends augmenting old water with fresh cold water to re-boil to the proper temperature. Perhaps this was because rare spring waters, coming from distant mountains might be so precious and therefore necessary to conserve the limited supply.

In the Song, by the time of Cai Xiang, water was no longer boiled in a pot or cauldron; instead, it was boiled in an upright, spouted porcelain bottle. The bubbles could no longer be viewed in the bottle; which is why he states heating the water is the hardest step in preparing the tea, since the water temperature could not be directly determined by bubble stages. Water boiled to the crab eye stage was considered the ideal temperature for preparing powdered tea. When the water was over-boiled however, the tea was essentially ruined.

Zhang Yuan, writing in the Ming Dynasty, further expands on what earlier tea writers said of the degree of boil—he makes a distinction between the former Song Dynasty method of poured tea to the steeped method of the Ming Dynasty. In the Song, tender water was preferred for infusing fine, powdered green tea. But by the Ming, whole-leaf green teas were favored; use of boiled water then changed from tender water to purely cooked water of the "Surging and Swelling Waves" stage. In order to best express the tea essence from the leaf, Ming Dynasty teas required higher water temperatures. Teapots (including *zisha* teapots) as steeping vessel also came into use by the Ming. When teapots were ripened (soured) by leaving tea leaves inside the pot for extended periods of time, it was unhealthy for brewing tea and tainted the flavor of tea infusions.

Xu Ci Shu, also writing in the Ming, establishes interdependency of tea, water, utensils (kettle and teapot), and fire; which are four mutually necessary elements for successfully steeping tea. Moreover, he prefers the use of metal kettles when boiling water; since according to ancient conceptions of the Five Elements, metal generates or gives birth to water. This is called reciprocal promotion, which is the reciprocal generation of the five elements: wood, fire, earth, metal, water. Specifically, the sequence is: wood generates fire, fire generates earth, earth generates metal, metal generates water, and water generates wood. That which generates was called the "mother" and that which was generated was called the "child." This is why Xu Ci Shu says metal is water's mother. If one accepts the concept of Five Elements; then metal kettles make the ideal water boiling vessel because metal directly generates or nourishes water. This is in contrast to the use of glass or earthenware kettles, which would be considered earth and do not have a direct connection to water.

Huang Long De says that hot water affects the tea's destiny; meaning if one has heated the water to the ideal temperature, then the result will be fortuitous. However, if one heats the water to an incorrect temperature—either too low or too high, calamity will result. Therefore, when steeping delicate green teas, the outcome of the water temperature determines whether the resulting tea infusion tastes delicious or disgusting.

Xu Bo stresses the fact that much poetic imagery was used in ancient times to describe the sound and appearance of heating and boiling the water. He quotes relevant verses from four different tea poems of the Tang and Song dynasties that describe the bubbles, ripples of boiling water, and the sounds the

boiling vessel makes as the water starts to boil. Much of this poetic imagery to describe boiling water was repeated again and again in tea poems and tea texts from the Tang until modern times. Note the repeated use of aquatic imagery to describe boiling water.

According to Chen Jian, in the Tang and Song, the powdered tea was infused only once and then consumed promptly. In contrast, by Ming and Qing times, because loose leaves were used, multiple steepings from the same leaves became possible. However, when steeped for too short a time, or after being steeped too many times, then the flavor became dull and lacking. And when over steeped for too long, green tea became dark, bitter, astringent, and vile.

THE MODERN METHOD OF BOILING WATER FOR TEA

Boiled Water was classed as the Three Boils and the Five Boils. Three boils in the Tang were "Fish Eyes," "Joined Pearls," and "Surging and Swelling Waves." The Five Boils in the Ming then became "Shrimp Eye" (very fine bubbles), "Crab Eye" (fine bubbles), "Fish Eye" (small bubbles), "Joined Pearls" (continuous bubbles), and "Surging and Swelling Waves" (rolling boil). Before these stages, the warm water was called "Baby Water." Past these stages, the tea was termed "Longevity Water" or simply "Old Water," meaning the water was boiled too long. "Tender Water" was another term to mean the Shrimp, Crab and Fish Eye stages. This water was especially suited to infusing tender green tea and was the ideal boil sought in Song and Ming times.

In Chinese Tea Art, or in Gongfu tea, much of this discussion about boiling water can add to the delight of preparing tea, since it is still important to recognize the stages of boiling water. Compare kettles by preparing a chart marking down time and temperatures to know the exact point when your kettle reaches say the Crab Eye stage without having to constantly monitor the kettle. A thermometer and timer are useful here.

It is important to note that since Ming times and earlier, green teas were nearly exclusively brewed. Therefore, water temperature and the degree of boil were extremely important. During the Qing Dynasty, Wulong (Oolong) teas and Red (Black) teas came to be developed, and only after the Qing were higher water temperatures required for steeping to bring out the essence of these teas. Today, the degree of boil and thus water temperature depends on personal preference, the type of tea, brew method, and brewing vessel.

The Taste of Tea

TANG DYNASTY

Lu Yu on Tasting Tea

In the *Classic of Tea*, under the chapter titled "Drinking Tea," Lu Yu writes of how tea should be ideally drunk: *"Drinking tea in summer, but abandoning it in winter, is not drinking tea."*[1] In Lu Yu's mind, to drink tea is to drink regularly, on a year-round basis. Month after month, day-by-day, tea should be drunk to one's content, while those who don't drink tea regularly don't understand tea at all.

Further on in the chapter titled "Tea Preparation," Lu Yu discusses under which conditions certain utensils can be dispensed with but still allow the tea drinking experience to be enjoyable. At the very end Lu Yu writes: *"But in the city, in the presence of nobility, if just one of the 24 tea utensils (used to prepare and serve tea) is forgotten, then it's best to dispense with tea."*[2]

Tea consumption during the Tang Dynasty was an elegant affair—if just one utensil were amiss, then it would be too unforgivable to drink tea in such a manner.

SONG DYNASTY

Hu Zai's "Three Don't Pours"

Song Dynasty tea drinking customs were similar yet different than those of Tang times. During the Song, green brick tea was customarily ground and powdered, scooped into shallow, rabbit-fur glaze bowls, and whipped to produce froth. This type of tea preparation was called "*dian cha.*" *Dian* literally means, "pour;" the hot water being poured from a spouted porcelain bottle with great precision, small amounts at a time, into the tea bowl. Then, by alternately pouring and whisking, the desired effect in the tea could be produced: first, the tea froth had to be white; second, the tea froth had to last for a very long time; third, fanciful designs might be made in the froth. These effects, when well executed and produced were all indicators of a person's tea skill.

Hu Zai, in *Collected Sayings of the Hidden Fisherman of Tiao River,* is the first to bring up the concept of "Three Don't Pours;" meaning when not to pour hot water; or when not to prepare and drink tea.[3]

Scroll Forty-Six

Dong Po Nine

Scholar Six One, Poem on Tasting New Tea[4] says:

"Sweet spring and clean utensils, fair weather and beautiful scenery, I choose to sit in the midst of fine guests."

Dong Po kept watch over Stone Pagoda Temple and drank tea there; he said in a poem: "In a Zen hut, near a window, there flows beautiful noon scenery,

From Shu well comes forth ice and snow;

Guests sit together in satisfaction;

Cauldron and utensils I personally clean."

This is what is meant by the proverb "Three Don't Pours."

What is meant by "Three Don't Pours"? First, look at the *"Poem on Tasting New Tea."* When we group the items mentioned into categories, we get a nice sum of three or three desirables to properly enjoy tea. The first desirable is new teas, sweet spring water, and clean utensils. The second desirable is good, sunny, warm weather and striking landscapes. The third desirable is fine guests who are talented, refined, scholarly, and of like mind and spirit. Together, these all make three desirable moments to pour tea, or "Three Pours."

"Three Don't Pours" are precisely the opposite:

1. Tea non-new, spring water non-sweet, utensils unclean: first don't pour.
2. Foul weather, ugly scenery: second don't pour.
3. Uncultured, rude guests: third don't pour.

Upon encountering any of these situations where the "Three Don't Pours" are observed, it's preferable to postpone tea preparation for a later date, as brewing tea when finding such unrefined situations would spoil the mood.

Hu Zai further supports this idea by quoting the poem by Su Dong Po. These "Three Pours" or "Three Don't Pours" can then be summarized as follows: The first involves the condition of the tea, utensils, and water. The second involves the condition of the environment in which to drink tea. The third involves the good manners and compatibility of the guests.

This idea reinforces what Lu Yu advised in the Tang Dynasty, when just one out of twenty-four utensils was amiss, tea was best abandoned; in Song times, when one of the "Three Don't Pours" was encountered, tea was best dispensed with.

"Three Don't Pours" serve as the ideal guidelines under which to prepare and drink tea. In Tang times, the ideal was to have all of the twenty-four utensils on hand. When these ideals are not met, then the enjoyment of tea for hosts and guests is diminished. Therefore, it would be a waste of tea and a waste of time to prepare tea under imperfect conditions, because the tea could not be enjoyed to fullest satisfaction. In the Song Dynasty, this idea evolved and came to also encompass not just the utensils, but also the tea, the water, the scenery, and the guests.

THE MING DYNASTY AND TASTING TEA

In the Tang Dynasty, tea art sprouted; gaining acceptance as a distinct beverage. In the Song Dynasty, tea tasting blossomed; becoming much more refined and elegant. By the Ming Dynasty, tea enjoyment matured and transformed into a highly

developed art evidenced by the ideas Ming tea masters put forth on tea drinking. Many of these tea book authors wrote commentaries detailing the proper, ideal circumstances under which tea should be tasted to attain fullest enjoyment.

Feng Ke Bin on "Yi Cha" — Proprieties for Tasting Tea

In the Ming, tea consumption rose to greater heights as tea drinkers had higher standards for imbibing tea. Long gone were the days of powdered tea, Ming tea drinkers preferred the tender buds of the earliest spring tea directly steeped in either a *gaiwan* or teapot. During the Ming Dynasty, a scholar named Feng Ke Bin wrote a treatise on tea called *Annotations of Jie Tea*.[5] In it he propounded "Thirteen Proprieties for Tea," and "Seven Tea Taboos."[6]

Proprieties for Tea

First condition: **No important matters**. When you can transcend the ordinariness of everyday life, and be free from the vulgarities of a mundane world, be free and unrestrained, natural and leisurely, you can better enjoy tea.

Second condition: **Fine guests**. One who is able to appreciate the aesthetics of tea, and appreciate art, and has noble interest in such activities, naturally will understand and realize the value of tea.

Third condition: **Tranquil and elegant sitting area**. When drinking tea in quiet and tasteful surroundings, calm and quiet atmosphere, may you be at ease and unconcerned about the affairs of the world for a moment.

Fourth condition: **Poetry recital**. Poetic verse instills an atmosphere conducive to tea drinking; tea helps cultivate a poetic mind.

Fifth condition: **Writing poems**. Tea aids clear thought and is helpful when putting ink on paper, whether to pen a poem or jotting down impressions and ideas.

Sixth condition: **Leisurely stroll**. Taking a walk through the yard or garden path to view nature scenes like a flowing stream, a thicket of bamboos, a gnarled tree, or a wayward flower can help gather your composure; cultivate a frame of mind conducive to drinking tea; and aid in endless delight when it comes time to drink tea.

Seventh condition: **Awaking from slumber**. Upon awakening, drinking some tea right away aids in purifying the mind and soul and refreshes the mouth.

Eighth condition: **Relieving hangovers**. Drinking fragrant tea aids in relieving the pains of a hangover and helps one sober up faster.

Ninth condition: *Qing-gong* **scenery**. As in a *qing-gong* painting, there should be tea snacks, fruit, and flowers to enhance tea enjoyment.[7]

Tenth condition: **Refined quarters**. The tea drinking space must be pleasant and elegant to foster a positive sentiment for tea drinking, adding to the plea-

sure of drinking tea. A tastefully decorated room will liven up an empty space to create a solemn and respectful atmosphere for tea preparation and drinking.

Eleventh condition: **Intimate understanding**. In brewing and sipping tea, try to foster in yourself and others a deep understanding of tea. You must become intimately involved in tea to prepare and drink it properly. In this way, can you raise your skill, virtue, learning and appreciation of tea.

Twelfth condition: **Appreciating things**. When you are knowledgeable and clear about the Way of Tea, will you then have the requisite experience to judge tea quality and appreciate tea. Tea is not about drinking, rather it's about tasting. Examine and judge the tea's flavor, color, fragrance, and shape; learn to appreciate the aesthetic and usefulness of the tea utensils.[8]

Thirteenth condition: **Cultured servant**. When there are intelligent and well-mannered tea servants to attend to tea service, throughout all aspects of tea service, from boiling water to serving the tea, great care and mindfulness should be taken to prepare tea properly.

Seven Tea Taboos
1. **Improper method**. When water is improperly boiled and tea improperly prepared, then tea is spoiled.

2. **Bad utensils**. When tea utensils are unsuitably matched, of low-quality, or stained and dirty, how can one enjoy fine tea?

3. **Uncharming hosts and guests**. When either hosts or guests are speaking rudely or ranting; and lacking in good manners, then tea is not to be served.

4. **Hats and garments in strict ceremony**. When one is too restrained by formalities of social etiquette, causing one to be ill at ease, then one will not have the repose necessary to fully enjoy tea.

5. **Indiscriminate numbers of meat dishes**. In order to preserve the original taste of tea, the mouth should be clean, with no heavy food tastes or odors. If heavy, odorous foods are served, they will overpower delicate tea, then the true taste of the tea cannot be appreciated.

6. **Busy and hectic lifestyle**. When one is busy with social activities and duties, then there is no time to properly appreciate and slowly sip tea. Tea is wasted when one does not have enough time for it.

7. **Cluttered and filthy room**. When the tea space is in disarray, full of garbage, and makes one feel disgusted, such a room is too vulgar for tea enjoyment.[18]

Chen Ji Ru on the Merits of Tasting Tea with Company

We find interesting commentary on tasting tea by Chen Ji Ru in *Majestic Affairs on Cliff Couch*. Here's what he says:

> *"In tasting tea, one person can taste tea's essence; two people can taste tea's delight; three people can taste tea's flavor; but six or seven people together can only be called using (drinking) tea."*

That is to say, one solitary person steeping and slowly sipping tea can fully experience tea's essence, its flavor and aroma. Since it's personally prepared, you then intimately understand the vitality and energy that is in the tea leaf brewed by your own hand. It is intimately tasted.

The act of brewing and drinking tea is a very sensual experience, especially when one performs it as a solitary act. It almost always seems a somewhat spiritual or mystical experience. When two people come into the equation, one person steeps, and two people taste tea; but it's not the same. If you don't have full control over tea brewing then somehow it just isn't a fully satisfactory experience. So two people take delight in tea, with host serving, and guest accompanying by sipping tea.

Two people drinking tea together are also more suited to experiencing the aesthetic taste of tea. This time, accompanied by a tea friend, one is more attune to physical surroundings and aesthetics of the tea utensils—leading to casual conversation about utensil choice.

When three people have tea together, they can taste tea's flavor and aroma. But because there are more people together to share tea, they may be less in tune with the aesthetic of the physical surroundings. Instead, they are more focused on mutual discussion and mutual relationships than the act of Tea. When three people get together to taste tea, often, the topic of discussion turns to each individual's favorite teas, and quite possibly, someone brings along their favorite. A group of three may then try both to host and guest tea. A trio of tea friends together do indeed taste tea's flavor.

In Fujian, when a large group gathers together, a single individual assumes the role of tea steward. Moreover, this person must pour and serve tea to all guests first, before he or she can pour a cup of tea for him or herself to drink. Sometimes the host rarely ever gets to taste the tea just brewed; when such a large group gathers, tea is not as enjoyable. The raucous of a large group is not conducive to the tranquil atmosphere necessary for contemplation over tea. So a large group of six or seven people together is hardly enjoying the aesthetic of tea and tasting tea, but instead is merely drinking it.

Gu Yuan Qing's Eight Requisites for Tasting Tea

In Gu Yuan Qing's *Tea Manual*, he expounds eight necessary requisites for sipping tea. The original in Chinese appears in list form, without any explanation:

Eight Requisites for Tasting Tea
One: quality (tea)

Two: spring

Three: boil

Four: utensils

Five: try tea

Six: heating fire, boiling water

Seven: tea companions

Eight: meritorious service

Expanding on Gu Yuan Qing's list of Eight Requisites for Tasting Tea:

First, good quality tea is required if one is to seriously taste tea, after all, "pin cha," to sip and taste tea, is about discerning and appreciating the quality of fine tea.

Second, fine spring water is vital to express the best flavor of tea.

Third, pay careful attention when "boiling;" which we can take to mean either brewing or steeping. To properly infuse tea requires considerable skill and talent: tea leaf amount and steeping time are important factors here.

Fourth, expertly crafted, pleasantly appealing utensils are required to express the best qualities of the tea's essence, and to foster a fuller appreciation of the tea; in contrast to poorly crafted or unclean utensils that function poorly, producing an inferior tea infusion.

Fifth, you must "try" the tea. Try means to sip and taste tea; also called "pin cha" in Chinese. When you try tea, use your heart to sincerely savor tea flavor, smell tea scent, observe leaf color and shape, and view infusion color; to understand the particular characteristics of the tea leaf and resulting infusion.

Sixth, in heating fire and boiling water, pay careful attention to water temperature. Maintain suitable water temperatures for the initial steep, and for subsequent steeps. Take care to prevent the water from boiling too long—which releases oxygen making boiled water taste flat.

Seventh, tea companions, especially those of kindred spirit enhance the enjoyment of tea by providing endless hours of discussion on tea related topics.

Eighth, apply meritorious service in preparing and serving tea. That is, be dedicated in method of tea preparation by steeping tea in a heartfelt manner. When serving tea to guests, ensure they are content with the tea. Remember to provide snacks and anything else your guests might require to enrich their tea experience.[9]

Lu Shu Sheng's Description on How to Taste Tea

In the Ming Dynasty, we find within Lu Shu Sheng's short book, *Tea Hut Chronicle*[10] a section titled "Seven Categories of Boiled Tea" where he expresses how tea is best tasted and enjoyed. Lu Shu Sheng's description of the tea tasting method is a very important one. Perhaps for the first time recorded in ancient tea texts, we get a very detailed description of how exactly to use the mouth in tasting tea. He also goes on to describe where to drink, with whom to drink, and why one should drink tea:

Tasting Tea

"When tea enters the mouth, one must first use that mouthful to rinse the mouth; then start slowly sipping; wait for the sweet saliva to moisten the tongue; in this

way can one taste the true flavor of the tea. If there is mixed in with the tea leaves any flowers or fruit, then the (true) fragrance and taste of the tea are all lost!"[11]

Attending the Tea

"Tea drinking is best suited to a veranda or a quiet room; near a bright window with a table of gnarled wood; in a monk's hut or a Daoist hall[12]; under moonlight silhouetted by bamboo thickets with wind blowing through pine trees; while sitting at a banquet and reciting poetry; while discussing matters[13] and reading scrolls."

Tea Companions

"Drinking tea is suited to literati and scholars; Buddhist monks and Daoist priests; old recluses and free, unrestrained people; or those of nobility who have transcended official titles and the desire to become important officials."

Tea's Merits

"Tea relieves annoyance, alleviates stagnation, purifies excessive alcohol consumption, awakens one from slumber, banishes thirst, and refreshes the spirit; during these times of drinking a bowl of tea does one benefit from tea's merits— which is no less than in the Tang when a Son of Heaven[14] painted and read scrolls in Soaring Smoke Pavilion!"[15]

Zhang Yuan's Elaboration on the Merits of Tasting Tea With Company

In his *Record of Tea*, Zhang Yuan seems to have directly expanded on Chen Ji Ru's earlier ideals of how one should best drink tea. He states:

> *"Drinking tea is most valued when there are few guests; where there is a multitude of people there is clamor; when there is clamor tasteful interest is lacking! Solitary sipping is called peaceful; two guests are called elegant; three to four people are called a delight; five to six people are called common; seven to eight people are called depraved."*

Drinking tea with a noisy crowd is clearly taboo—tea is not fully enjoyed with such a racket. In Zhang Yuan's ideal conception of the pleasures of tea enjoyment with guests, anywhere from one to four people are acceptable for taking in the delights of tea. In the original Chinese text however, he seems to emphasize drinking tea in solace as the most ideal way to fully enjoy tea; and the higher the number of people, the further away one gets from the ideal of tasting tea or "pin cha."

Zhang Yuan then goes on to state more clearly the specific method of drinking tea by writing:

> *"Pouring is not suited too early; drinking is not suited too late. if early, then the tea essence has not yet developed;. if late, the wonderful fragrance has already dissipated."*[36]

This statement is actually quite correct. Drinking before the tea is allowed to steep for the proper time length results in a totally unsatisfying infusion; while drinking the tea too late, allowing it to go cold in the cup, results in an off flavor and aroma. Try that with a green tea, and then you will immediately understand.

Wen Long's Specified Times for Drinking Tea

In *Annotations on Tea*, a Ming Dynasty tea book, Wen Long prescribed six specific time periods each day when tea should best be taken. He writes:

"Tea drinking has fixed times each day: pre-dawn, breakfast time, forenoon, meal time, evening, and at sunset; altogether there are six recommended times. But when guests visit making tea brewing again necessary, this does not count."

So there are six ideal times during the day best suited to the enjoyment of tea:

1. Pre-dawn, upon awakening, to invigorate the body.
2. Breakfast time, tea to relax after breakfast.
3. Forenoon, tea and snacks to satisfy noon hunger.
4. Meal time (the second meal). While waiting for dinner to be cooked, and after dinner to relax.
5. Evening, for rest and relaxation.
6. Sunset, as the sun goes down, perhaps with a snack, to satisfy the stomach.

Wen Long's habit of drinking tea six times per day meant to go a day without imbibing the jade nectar was unthinkable. When guests visited however, the customary courteous rounds of tea brewing did not count into the total prescribed daily tea breaks; they were considered additional to the sixfold daily drinking regimen. This is perhaps, the first tea drinking schedule! Wen Long also wrote tea drinking prevents illness and old age. Therefore, a daily dose of tea is life-restoring and vital.

Of course, the lifestyle of Ming-era Chinese was quite different from the hectic world in which we now live. The rhythms of life—the times we take meals, go to work and rest, these have all changed. The ancients lived by the sun: arising with the sun and resting when the sun went down. Chinese lived an agrarian lifestyle, which is very much evident even today, particularly for tea farmers. Perhaps most of us are not awake yet at five in the morning, but when we do wake up it is nice to have the fragrant scent of tea to awaken our senses. Tea with our meals is quite welcome, too. Then, in the evening, another session of tea is in order to wind down our day. Of course, some tea before bedtime is enjoyable, but not too much. Wen Long's tea schedule is certainly workable for us today.

Ancient Chinese Reckoning of Time

Since the Qin Dynasty, Chinese divided the hours of the day into 12 time periods; each period lasting two hours. These time periods had specific names and often many variant names. Each time period followed the position (or absence) of the sun, daily life activities (like breakfast time), agricultural activities, and

so on. Just as today we would say "noon" or "midnight," to mean a specific time period, Chinese had names for their own specific two-hour time periods.

In *Annotations on Tea*, Wen Long mentioned the following time periods: Dan Ming (pre-dawn), *Yan Shi* (breakfast time), *Yu Zhong* (forenoon), *Bu Shi* (meal time), *Xia Chong* (evening), and *Huang Hun* (sunset). Here is a description of each of the time periods he mentions as ideal for a tea break:

1. *Dan Ming* 旦明. 3A.M.–5A.M. This is early morning before sunrise. It's the period when there is twilight, but the sun hasn't yet appeared on the horizon.
2. *Yan Shi* 晏食. 7A.M.–9A.M. This corresponds to our notion of breakfast time. This was the period when ancients ate their first meal of the day.
3. *Yu Zhong* 禺中. 9A.M.–11P.M. Forenoon. This time was observed when the sun appears between Hengyang mountain 衡陽山 and Kunwu mountain 昆吾山. It's alternatively written in Chinese as 隅中.
4. *Bu Shi* 餔時. 3P.M.–5P.M. Late afternoon meal time was the time when the evening meal was eaten.
5. *Xia Chong* 下舂. 5P.M.–7P.M. Evening sundown occurs when the sun starts going down, setting into the mountains.
6. *Huang Hun* 黃昏. 7P.M.–9P.M. Sunset (literally, "yellow dusk"); is the time when the sun has already set, but the skies have not yet darkened.

Tea Tasting Environment

Enjoyment of tea is directly dependent on the presentation of tea: this is tea

psychology. If the surroundings and environment are beautiful, then it is more conducive to an enjoyable tea experience. The same criteria apply to tea utensils; to enjoy good tea, you need fine tea utensils. If the utensils are ugly, enjoyment and experience of tea is lessened. If it is less enhanced, then the whole perception of the tea and the tea experience becomes less enjoyable.

Certain factors are crucial to creating a good tea drinking environment. A clean, neat, well-ordered, comfortable, convenient, beautiful, refined, quiet environment all contribute to creating a mood conducive to tea enjoyment.

Indeed, throughout the culture of tea in China, we see how important the tea environment becomes. Since ancient times, tea scholars presented concrete ideals for the fullest enjoyment of tea.

As already described, in the Song, the ideal environment for tasting tea, according to Hu Zai, was one of fair weather and striking landscapes. In the Ming, as stated by Feng Ke Bin, it's best to have a tranquil and elegant sitting area, in a refined room, where elements such as tea utensils are laid out as in a *qing-gong* painting, and it's helpful when you have an appreciation of tea utensils and surroundings. Lu Shu Sheng then further elaborates that drinking tea is best suited to a quiet room, near a bright window with a wooden table, or in the mountains among bamboo thickets with winds blowing through the pines. Tea drinking is further suited to intelligent discussion and reading; and the company you are with when drinking tea, whether alone or with friends, also adds to an enjoyable environment. Gu Yuan Qing also mentions meritorious service as important for tasting tea. Of course, how the tea is artfully prepared also adds to the atmosphere of the tea-drinking occasion.

On the other hand, a bad environment for drinking tea is one that could have any one of the following: ugly scenery, poor tea preparation skills, poor or dirty utensils, unrefined guests, very formal and constrictive environment, a cluttered and filthy room, too many guests.

From a distinctly Chinese perspective, additionally, nature is integral to the enjoyment of tea. The placement of stones, arrangement of potted plants—suggestive of mountains and forests, and the use of natural materials such as a wooden table, bamboo stools, and earthenware or porcelain utensils with naturalistic decoration all add to the enjoyment of tea as a product of nature.

From all of this, as tea scholars of the past have stated and I concur, refined and exquisite tea utensils enhance the enjoyment of drinking tea; although skillful tea preparation is also essential. These, along with refined decoration of the room and seating area are all conducive and act collectively to produce an enjoyable tea tasting environment.

Tea Etiquette

The term *Cha Li*, meaning tea etiquette, has a long history in China.[1] It was a necessary act performed as a social courtesy for the benefit of society. The idea for the later foundation of *Cha Li*, although not mentioned specifically, is found in the *Book of Rites*. Contained within this historical-philosophical classic are many descriptions of *Li* or etiquette essential for society.[2]

The Importance of Etiquette in Tea

In Chinese, there is a common saying: No tea is discourteous.[3] Meaning, to not offer tea to guests is improper etiquette. Tea is an essential element of the social norms of courtesy, etiquette and manners in China.

The *Book of Rites*, a document from the Warring States period, details the importance of propriety in daily life. As the foundation for many other later thinkers, the writings of this venerable classic have an impact on tea, particularly the tea ceremony, as practiced today.

Recorded in the *Book of Rites*, there is an interesting passage in the Li Yun Chapter.[4] This period in history was very chaotic, and Confucius believed proper etiquette was the best way for society to return to good health. In this discussion between Confucius and one of his disciples, the disciple asks of Confucius:

What is the proper way to conduct government? Confucius replies:

> "In etiquette, previous rulers held up Heaven's Way. They administered the peoples' situation. But those that lost the Way died; those that held onto it lived. *The Book of Odes* says: "The rat has a body (*Ti*), but people don't have etiquette (*Li*)?[5] If people don't have etiquette, why don't they just all die early?"

Although this commentary applies to how government affairs should be handled, it can also be applied to the Tea Ceremony. One may practice tea possessing full knowledge of the varied tea utensils and their many functions; but without etiquette, is this really practicing tea? For people, etiquette is a basic element of our being, just as the body and limbs are so vital for the rat to live and function. Without the human element of etiquette what is the use of serving tea? Courtesy, etiquette, and manners, therefore, are all fundamental components of tea practice.

When serving tea to guests, always serve elders and respected guests first before serving all other guests. Lastly, you, as host, may pour yourself a cup of tea. When each time, someone finishes their cup of tea, always immediately re-fill their cup. When guests discontinue drinking their tea, by leaving a full cup, it is a polite non-verbal cue that they have had enough tea. Or sometimes, if the guest is a familiar friend, he or she may overturn their cup and place it on the *chapan* (tea tray), signaling that they are finished drinking tea.

When making tea, your multiple actions—preparing, steeping, pouring, serving—all possess the indelible mark of your character, personality, moral

discipline, and most importantly, your skill in brewing tea. Be self-aware of behavior and execution, both intentional and inadvertent in tea preparation.

Cha Li and Sacrificial Offerings

The obligatory duty of making sacrificial offerings at certain periods during the year was practiced since ancient times in China. From the *Book of Rites*, we learn at specific times, sacrificial offerings to the ancestors were required; but offerings should not be done often. If done often, they would be troublesome, and if one felt troublesome, one is then inclined to be disrespectful. On the other hand, sacrificial offerings should not be done infrequently. If done uncommonly, one would slack off. And if one slacked off, one would then forget.[6] Extremes in offering sacrifices, either frequently or rarely, produced unintended and undesirable consequences. Offering sacrifices in moderate frequency, occasionally, was considered most sincere and appropriate.

Tea, from the very beginning, was originally used as a medicine: to cure sickness, restore vitality, and prevent death. For this very reason, tea became revered for its curative properties, endowed with mystical properties. Tea early on then became considered a potent force of immortality; the elixir of immortality. Because such high esteem was attributed to tea, ceremonies such as sacrificial offerings and offerings to ancestor spirits could not be performed without the inclusion of tea offerings.

Since the Southern Dynasties period, the emperor, Wu Di Xiao Ze of the Qi Kingdom[7] (ruled 483–494 C.E.), instructed the royal court: "*After my death, in front of my spirit, never use animals as sacrificial offerings to me. You only need to*

offer cakes, fruit, tea, rice, wine, and preserved fruit; that is all."[8] This account is recorded in the *Classic of Tea* in Chapter 7.

There is also related in the *Classic of Tea* a curious, mystical story about the importance of tea as a sacrificial offering. In Chapter 7, the story states:

Yi Yuan[9]

In Yan County[10], Chen Wu's wife lived with her two sons in widowhood. She liked to drink tea very much. In the place where they lived, there was an old tomb. Every time she drank tea, she would first make offerings of tea. The two sons felt it was harmful and so complained: "What does an old tomb know? It's a waste of effort!" These two wanted to dig out the tomb. But the mother earnestly persuaded and sternly forbid them to do so. That night, she dreamt of a man saying: "I have been within this tomb for over 300 years. Your two sons constantly wanted to destroy and flatten it. Luckily you have protected me and you also offer me fine tea[11] in sacrifice. Although I am in the netherworld and nothing but bones beneath this earth, however, how could I forget this debt of gratitude?" When day broke, there could be seen in the courtyard a stack of one hundred thousand copper coins strung together[12]. They looked as though they had been buried for a long time. Only the string holding them together was new. The mother told her sons all that had happened. This made the two sons feel very ashamed. From then on, offering of sacrifices became more common and important.

We see in this story an illustration of filial duty, making sacrificial offerings, paying respects to the dead, and the importance and use of tea in sacrificial

offerings all playing a fundamental role in ancient Chinese society. There is a special duty of the living to make sacrificial offerings to the ancestors. Use of tea in prayer offerings fulfills a critical function: such offerings of tea not only benefit the departed souls, they also benefit the living. From ancient times until today in China, tea still serves as one valuable component out of many types of sacrificial offerings.

Cha Li and Guests

In Fujian, when guests come to visit, in most natural fashion, the host starts a fresh kettle of water to boil. Then, sitting on sofas, or perhaps wooden log stools or even squat bamboo chairs, the host will prepare tea in an elaborate way on an impressive *chapan* (tea tray). On the tea table, there may be set various snacks: melon seeds, peanuts, fresh fruit, dried fruit, candy, and other assorted delectable treats.

When guests come from afar to visit and as host receives guests, isn't it wonderful to be greeted, warmed and comforted by a steaming cup of fragrant tea? To invite guests to drink tea is a very natural custom of the Chinese people.

During the Jin Dynasty, there was a very frugal official named Lu Na. He was a prefecture chief in Wu Xing[13]. One day, a general named Xie An came to see him. Lu Na had the habit to only offer tea and snacks to receive guests. But Lu Na's nephew resented Lu Na's stinginess. So one day, this nephew took it upon himself to set a large table arranged with many dishes of meat, fish, rice, wine, and vegetables to entertain the guests. After the guests left, Lu Na beat his nephew with 40 lashings of the cane. As elder Lu was beating him, he

angrily scolded: "You can't bring any honor to your uncle! You just tarnished my simple and frugal home. This is so detestable!"

Also during the Jin Dynasty, there was an important official named Huan Wen. History records him as also being a naturally very frugal person. Whenever he invited guests over for a large banquet, awaiting the guests were just seven trays of tea and fruit! Perhaps the entertainment was richer than the food and drink; and the invited could satiate themselves on a fanciful feast of lyric and color.

But at this period in Chinese history, inviting guests to attend wine banquets where extravagant sums were spent were all the more common. So tea became a very important substitute, to counter the corrupt debauchery of drunken disorderliness. Tea was a refined and pure pursuit. Tea could keep one's senses alert, instead of stupefy like wine. At banquets, tea consumption was then promoted as a much better substitute for excessive wine intake.

Afterward, the custom of using tea to show respect toward guests slowly gained popular acceptance, gradually becoming a widely adopted social custom. A similar idea reinforcing this sentiment was discovered within an ancient text unearthed from Dunhang[14], written in the Tang or Five Dynasties period called *Discourse Between Tea and Wine,* authored by Wang Fan Zhi. In this rediscovered volume, he reasons that tea is:

"The head of One Hundred herbs, blossom of Ten Thousand trees. The most valued of all flower buds selected, most important of all shoots picked. Called *Ming* herb, named *Cha*. One of five tribute items out of the nobleman's mansion

respectfully presented to the families of emperors. Stylishly presented, a lifetime of high status. Naturally esteemed, what use to boast?"

This text also claims wine is a destroyer of households, and widely used for wicked vices. Tea consumption, therefore, for people of the Tang Dynasty, began to be valued as much or perhaps even more than wine. During this period, historians also made the observation that social customs should value tea, because tea consumption is beneficial to the people.

"Distribute tea"[15] was an ancient term used in the Tang Dynasty as a custom to brew tea to offer and entertain guests. We see in Han Hong's *For Tian Shen Yu Thanks for Tea List*[16] the following:

"Host Wu is courteous and virtuous; he is well-learned and erudite in preparing tea. Official Jin is a fond Guest of Tea. Just now has he distributed tea."[17]

During the Song, fancy tea banquets became quite fashionable, which was an elaborate way to entertain guests. At these banquets, tea was the theme and a very integral part. Not only did Song nobles spend great sums in preparing exotic dishes, but they also spent lavish fortunes on exotic teas, utensils, and tea service, which was probably the highlight of the meal. At that time, many literati and others skilled in tea preparation held tea contests to compare their skill and to demonstrate the superiority of their tea. In the Song Dynasty, powdered green tea whipped to froth was used. They prepared powdered tea in small, shallow bowls called a *zhan*[18]. The preferred bowls were black and glossy

from the Jian kilns in Fujian. Using a small bamboo whisk, each tea participant whisked their bowl of tea. Skill was demonstrated in producing froth on top of the tea. The froth had to be white, and it had to last a very long time. There were even different styles of froth that could be whipped into the tea. Tea making in the Song was a very skillful affair with very stringent requirements: not only must the tea taste refreshing and delicious, but tea preparation must also entertain and enchant participants.

Literati endured a peculiar lifestyle from that of court officials, or the royal family. The ancient literati had a tradition of leaving the common world behind, retiring to the mountains to live as a recluse for a time. Daring to lead such a rustic, arduous life had its benefits: when they returned to the common world, they would become even more famous. When they were appointed to an official post, they might compose several sentimental poems recollecting the reclusive feeling in the mountains. In the literati's experiences, throughout their time of wanderings and travels, they would mix with officials of high status, literati and monks, discussing the virtuous path, and other philosophical matters while at the same time imbibing tea or wine. Lu Yu was exactly this typical type of literati. He was found abandoned as a baby by a monk and raised by Buddhist monks until the age of 12—though he did not become a monk himself. It was during his time living in the temple and serving his benefactor that he was first exposed to tea, and taught about its proper preparation and serving. Lu Yu possessed very intimate knowledge about tea transmitted by monks who personally cultivated and drank tea. His early education focused on preparing tea, memorizing the classics, learning to read and write.

During Lu Yu's duties as child-servant of his benefactor, he engaged in brewing and serving tea to the satisfaction of master and guests. In the Song Dynasty, they had a special term to invite guests to tea: *bai cha*[19] or courtesy tea, a respectful term to invite guests to pay a visit and have tea. Of course, when the literati received guests, their vitality in tea preparation and their moral character was purer than most. The literati often composed tea poems together while drinking tea; many of which have been left for us to appreciate.

Extolling the virtues of delicious spring water; tending to a hot, vigorous fire; fanning to exact proper water temperature; cleaning treasured tea utensils; sipping tea slowly and mindfully; enjoying tea to the fullest: such was the magnificent art of tea practiced by Ming era tea masters. (We have already seen examples of these in the passages from ancient texts throughout this book.) In the Ming era, when good friends came to visit, one had to offer high quality tea; prepared and served in equally fine utensils. When visiting someone's home, the first thing one would hear shouted by the host is: "Bring on some tea!"[20] Many references to such a reception, such as when a servant girl brings tea in to serve host and guests, is found in the novel *A Dream of Red Mansions.*

An expression for thoroughness in providing food and drink to guests in the Ming era, literally meaning "three teas six meals,"[21] was a phrase used by either host or guests to mean the meals and drink were abundant. So hosts had to be very generous when entertaining guests with food and drink. This expression is also found in *A Dream of Red Mansions.*

Other tea-specific terminology dealing with tea and guests is also found within the Chinese language. For example, "proffer tea"[22] meant to invite guests

to drink tea. The term "see to tea"[23] meant call family members or servants to carry in tea for guests. These very common phrases, used in the Ming and Qing era, likewise are found in *A Dream of Red Mansions*.

What about guests who, when offered tea, didn't drink it? There is an ancient term for them too. They were called "wicked guests."[24] In the Tang, Yuan Jie in *Yuan Ci Shan Ji* calls these non-tea drinkers "wicked guests," perhaps because historically, Northerners were ignorant about tea and therefore uncultured in the ways of tea, and perhaps partly because wine customs were also very popular. Of course, with wine consumption, there is drunkenness, a muddled mind, and other negative aspects of intoxicants. Moreover, there is much etiquette involved in tea. And if one did not drink tea, then much of this etiquette could not be carried out correctly for the proper functioning of society. This term "wicked guests" is also in a poem by the Song poet, Huang Ting Jian. "Wicked guests," however, was not exclusively a tea term, when such a label was applied to alcohol abstainers, it carried the same connotation.

Cha Li and Marriage

Cha Li is an integral part of marriage. The term *cha li*, in ancient times often meant the contract between parties for engagement and marriage. It was customary to pay the bride's family in many gifts, tea being one of them. So *cha li* could also mean the engagement gifts of tea offered to the bride. Tea, offered in this way, became a token of love and marriage.

I should point out here that China is a very large and diverse country in terms of people, geography, environment, languages, and social customs. Tra-

ditional wedding customs in each region and every city of China therefore, differ greatly. However, tea is always an important aspect of the rituals of engagement and marriage. The tea plant was regarded as an esteemed and beneficial organism. When blossoms opened and fruits ripened, the seeds continued the generation of new tea seedlings. A tea seed does not stray far from the mother plant, so the ancients observed, symbolizing a stable marriage and a flourishing family. Porters in the groom's entourage, with bamboo pole hefted over the shoulder, carrying two loads of tea and other gifts encased in wooden carry chests to the red-garbed bride, was an important obligation.

As early as the Tang Dynasty, during the time of Lu Yu, historical documents record that the Tibetan king already had different teas from many areas of China. But it wasn't until Princess Wen Cheng married into the Tibetan royal family to King Songtsän Gampo during the Tang Dynasty (around 641), bringing many marriage gifts with her royal entourage into the Tibetan palace, including tea and tea utensils—whereupon she reputedly taught palace maidens how to boil buttered tea—that tea consumption among Tibetans was widely practiced, to supplement a diet of mainly meat and fat. So at least since Tang times, marriage and tea went hand-in-hand.

After the Tang period, tea then became a common symbol of engagement. Thereafter, there entered the Chinese language a profusion of tea associated wedding terms. For example, when the man's party sent the woman's family engagement presents, this was called "send down tea."[25]

Xu Ci Shu's tea book, *Explanatory Notes on Tea* states:

> "Tea doesn't move from its origin. The plant must bear seed. When the ancients got married, tea necessarily was the present. It took the meaning of the tea plant not moving away from the seed. Today's people still call this ceremony 'send down tea.'"

Ancient Chinese held the custom of presenting lavish engagement or wedding presents, which included tea and other precious articles, like gold, silver, or money, this dowry was known as the "tea price."[26] If a woman accepted the engagement, she would also have accepted the tea, to which people would say she "had already drunk tea."[27] Moreover, "receive tea"[28] meant the woman accepted the engagement present, and thus the wedding proposal. When the woman's family consented to the wedding between the prospective bride and groom, they were deemed to have "accepted tea."[29]

"One family's daughter doesn't drink two families' tea"[30] was yet another marriage expression meaning a woman can't be engaged (or married) to two husbands. If a woman already drank the tea of an offering male; then she effectively already consented to marry him. She cannot therefore, accept another offer to drink tea arranged by another man's family. On the other hand, "never drank tea"[31] referred to a woman who was not yet engaged.

"Implement tea"[32] in old times meant when the marriage date was decided, the man's party would send tea to confirm and set the date with the prospective bride's family; thereby sealing the marriage contract between both parties.

In Hunan, there was a custom when holding the wedding ceremony to sing a song praising the fragrant tea. This was called "tea praise."[33] It was used as a

form of congratulations. A poem by Li Li titled "Chrysanthemum Stone"[34] mentions "tea praise:"

"After drinking wedding tea, tea praise is necessary. One person takes the lead, everybody sings, how can you forget the customs of years past?"[35]

During the wedding ceremony, bride and groom customarily kneel together before the parents, respectfully serving them a cup of tea. This was known as "kneeling tea."[36]

On the wedding night, it was the Chinese custom for all the men to go to the groom's bedroom and all yell together. This was called "make noisy tea"[37] or "uniting tea."[38] But they were only allowed to express a limited amount of affection toward the new bride. At the same time, the groom's family could not say nor mind very much, so as not to ruin the celebratory fun.

After being newly married, the new bride would send gifts of tea home. This was called "send tea;"[39] it was basically the concluding ritual of the wedding ceremony.

Of course, no wedding would be complete without a huge wedding banquet with the entire family in attendance. Today in China, these banquets are usually held in a large restaurant, with perhaps 600 people participating, from young to old. They often have two banquets: one in the afternoon, and again in the evening so as to accommodate the entire extended clan, close friends, and colleagues. A splendid repast is laid out, including many delicacies. After eating a few morsels, in customary duty, bride and groom take their glasses toasting

each individual by drinking wine or beer. Since there are so many relatives sitting at each table, one could become drunk in just a short space of time. Tea again has a crucial function, either as a non-alcoholic substitute in toasting, or to awaken one and counteract the ill effects of excessive alcohol consumption. Tea rituals play an integral and vital role in Chinese wedding ceremonies.

TEA AND OTHER CUSTOMS

"Seven Households Tea"[40] was an old custom of Hangzhou. At the Beginning of Summer (Li Xia) on the Chinese calendar (on May 5 or 6), each household brewed new tea, distributing it to the neighbors. Hangzhou residents had to brew and serve tea to three households to the left of their house, and three households to the right of their house. That would make a total of seven households involved in the activity; giving rise to the name Seven Households Tea. This annual ritual was performed as a sign of respect, a way to socialize with neighbors, helping families develop and maintain good community relations. As recorded in a Ming Dynasty historical text by Tian Ru Cheng's *Extra Record of West Lake Excursion,* this was an extraordinary, extravagant affair:

> On the day of *Li Xia*, each household brews new tea; accompanied with various small fruits. They present the tea as a gift to their close neighbors; this is called Seven Households Tea. Rich families compete to extravagance: the fruits are all elegantly carved, adorned with gold leaf; the varieties of teas were of vari-

ous prestigious sorts, including: Jasmine, Crabapple,[41] Rose,[42] Osmanthus Flower Bud,[43] Lilac Sandalwood,[44] Jiangsu Apricot.[45] They were contained in Ge[46] or Ru[47] porcelain bowls. Each bowl supplied enough tea for only one sip.

New Year's Tea,[48] another Chinese custom during Spring Festival, involved visits by relatives to drink tea and eat snacks including fresh fruit, preserved fruit, melon seeds, nuts, candy, and other tasty bites. When these family members came to visit, tea and snacks were a necessity to have available. Reference to this custom is also found in *A Dream of Red Mansions.*

These scant examples of tea customs are but a few out of numerous tea traditions still practiced in China, which vary depending on location and ethnicity of the people. Discussion of these other tea customs however, is perhaps best left for another time.

Refinement in Tea

TEA ENVIRONMENT AND TEA ENJOYMENT

Exhibited previously in Chapter 4, fostering or creating a suitable tea environment is an important component of a pleasurable tea experience. Creation of a cordial tea environment, a vital aspect of *Chayi*, fosters and encourages an enhanced tea experience for guests. Professionally, tastefully designed and decorated teahouses of many styles are found throughout China. Before we look at those styles, let's examine some of the modern environmental elements specific to teahouses that are so necessary for tea enjoyment.

Comfortable environment. Meant as a place for guests to relax while leisurely sipping tea, a special tea room ideally contains the following elements: convenient layout (allowing for easy tea preparation, brewing, drinking); spacious interior (enabling guests to feel comfortable—which is especially important when handling scalding liquids); sensible arrangement (of furniture and utensils within the room—place the kettle within easy reach, for example).

Relaxing environment. Achieve a feeling of exhilarant relaxation through choice of comfortable chairs and furniture, muted lighting, soft background music—instrumental, nature sounds, *guzheng* (Chinese zither).

Clean environment. Avoid filth and clutter so guest don't become disgusted. Aim for a clean, ordered, organized space—ensure washrooms are spotlessly clean; clutter gives guests a feeling the space is either too busy or too small.

Inviting environment. An inviting, warm, welcoming space allows guests to feel cozy and at ease, increasing chances of frequent visits. In addition to a large, open space with tables and chairs for seating, allowance for private and semi-private seating areas affords privacy to guests.

Functional environment. A multifunctional environment, with capability to accommodate meetings and dinners, besides tea service, adds value to the location. Private rooms—perhaps equipped with a television, video player, and other audio equipment adds functionality and usefulness. The space could even be business functional—equipped with wireless internet and convenient access to electrical outlets to plug in digital devices.

Charming environment. An arresting tea space possesses unique characteristics (making it memorable in the minds of guests from the numerous restaurants, tea shops, and other venues guests might frequent); fostering a vivid, favorable impression.

Natural environment. Because tea is a product of nature, introduction of natural elements into the tea space is beneficial to cultivate an immersive tea realm. Employ nature inspired surroundings to create a soothing, refreshing atmosphere—floors and steps of natural stone; walls decorated with stone; rich interiors with beautiful wood grains and wooden furniture; an abundance of low-light tolerant plants arranged in rows and throughout the space; a thicket of ornamental bamboos placed in strategic location, suggestive of forests; smooth

river rocks set in an imitation stream to suggest flowing water; lotus or water-lily ponds—all of these can be incorporated into a tea space.

Most desirable is a refined aesthetic atmosphere, creating an enriched tea space with an elegant, exquisite interior. The walls may hold Chinese calligraphy of the "tea" character; scrolls of Chinese poems in beautiful calligraphy; or simple paintings might adorn walls. The porcelain or *zisha* tea ware itself could serve as an artistic display, sitting majestically on shelves one above another.

Incorporating all of these elements cohesively together contributes to an environment much more enjoyable for tea, but whatever manner the space is created, above all else, guests' interest and enjoyment of tea should remain the foremost concern.

THE TEAHOUSE

A teahouse is a place that specializes in the expert preparation and serving of tea. It's the ideal resting place to sip and enjoy a steeped beverage.

Teahouses have a very long history in China; Although there are no definitive records of the earliest teahouses, there are records dating to the Western Jin Dynasty, recorded in the *Classic of Tea* containing a reference to selling prepared tea beverages to drink. So it can be assumed, that by Western Jin times (256–317 CE), teahouses had already appeared in China.

During the Tang Dynasty, there are much more specific anecdotal records of teahouses, as we find in *Feng Shi Wen Jian Ji*. It states:

"In the capital and in the cities, there are many shops opened that sell brewed tea. They don't ask about your desires. Just put in your money and take the drink."[1]

This historical account proves that by the Tang Dynasty teahouses were already relatively common. But it wasn't until the Song Dynasty that we see the blossoming of teahouses. During Song times, the economy flourished, and along with it, society advanced greatly with notable contributions to science, literature, the arts, and tea customs. Along with this further development of tea culture in the Song was an increase in the construction of many teahouses throughout the entire country.

In the Song Dynasty, in addition to *"cha guan"*[2] or teahouse, there appeared many other words in the Chinese vocabulary that meant "teahouse." Some of these included *"cha fang"*[3] or tearoom, *"cha si"*[4] tea shed, and *"cha lou"*[5] or storied-teahouse. We see mention of a *"cha fang"* in the famous Song-era novel *Water Margin.* A line in Chapter 3 reads:

"When Shi Jin went to enter the city to take a look, as before, there were six roads and three streets. He only saw a very small tea shed, right at the intersection."[6]

The Song Dynasty saw many types of teahouses that served as places to rest, to enjoy the delights of tea. They also served a dual but very important function in society by providing a place to conduct business and socialize with friends.

In the Ming Dynasty, teahouses continued their development, but at this stage, tea brewing methods changed to steeping leaves in hot water. The focus

shifted to the quality of the loose leaf, utensils required for tea brewing and drinking, and tea brewing skill. Tea house guests found the entire tea preparation process, variety of tea utensils, and numbers of tea varieties all fascinating. At the same time, in the capital Beijing, Big Bowl Tea came into fashion, where large bowls were filled with tea and sold from stands on just about every street corner. To quench thirst, passersby could conveniently purchase a bowl of tea; the large, crude bowls provided enough drink to satisfy any thirst. Out of 360 occupations, beverage tea service then became recognized as one of the standard professions.

Sometime after the 1950s, teahouses began to change anew. Now, they became places to not just quench the thirst and rest, but also venues for entertainment, places to hear news, locations for meetings. At this time, most of the teahouses were located in scenic tourist cities, and in southern China (northern China seldom had teahouses). Considered one of the low points in Chinese teahouse history, during the Cultural Revolution period from 1966–1976, teahouses were, albeit briefly, nearly on the verge of extinction in many parts of China.

In 1977, *Chayi* or Tea Art was developed in Taiwan; with the first *Chayi Guan* or *Chayi* Teahouse opening in 1979. Later, the concept spread to Hong Kong and throughout the rest of China. It was a new development; a refinement of the old traditions directly leading to a rise in tea culture. With the renewed emergence of tea culture came revived development and construction of *Chayi* teahouses, or Tea Art teahouses.

Today in China, if you visit a teahouse, it will likely be a *Chayi* teahouse, where you can experience a performance of Tea Art, which is the preparation of tea in a stylized and artistic manner.

TEA MASTER

A practitioner of Chayi or Tea Art may be called *chayi shi*[7] (Tea Artist), or *cha boshi*[8] (Tea Master). Of course, *Chayi Shi* or Tea Artist is a modern appellation; but *cha boshi* is a very ancient title.

The word *boshi* was a title applied to some members of the Imperial Academy (Han Lin), which was where literary works were stored and studied by the emperor. The word "*boshi*" was originally a title for a posting as an imperial official, originating in the Warring States period, but it soon came to refer to officials of any specialization. In the Jin Dynasty, there were "legal studies *boshi*;" in the Tang Dynasty there were "medical studies *boshi*," and so on. Later on, the term was even more broadly applied from the original title of a government official to one of a person possessing a skill. We then see titles for occupations like "wine *boshi*," "massage *boshi*," "pagoda construction *boshi*." Therefore, anyone who had a skill of any sort, no matter how questionable, could be called "*boshi*." The term became downgraded, losing credibility as a definition for expertise.

Of course, "tea *boshi*" could be included among this list. To be a "*cha boshi*," like any profession, at first was a lowly one. It primarily meant a tea waiter (a lowly servant or lackey who simply prepares and serves the tea either in a teahouse, or the private servant of the wealthy), but in later times tea *boshi* became a more esteemed profession.

During the Song, when teahouses were ubiquitous, the term "*cha boshi*" or tea master was applied to teahouse employees. With respect to tea, the exact

definition of master means someone who has attained a high degree of professional skill. The tea master was then someone very skilled and knowledgeable in choosing, preparing, brewing, and serving tea. We see the term tea master in Chapter 18 of the novel *Water Margin*:

"Song Jiang called the Tea Master to bring two cups of tea over."[9]

The term "*cha boshi*" simultaneously meant a teahouse waiter or servant and a tea seller. But the term tea waiter was a belittling title. These professionals possessed great skill in preparing tea for guests. Somehow, tea master seems a better title than tea waiter. In the Tang Dynasty, the term tea waiter was used to belittle the greatest tea master of all: Lu Yu!

Perhaps the earliest record of these *cha boshi* can be seen in records of the Tang Dynasty in Feng Yan's *Feng Shi Wen Jian Ji*. It states:

"After the tea was finished, he ordered the servant to take out thirty *wen*[10] to pay the tea waiter."[11]

The tea waiter recorded here is none other than Lu Yu himself. At that time, Imperial historian, Li Ji Qing went to Jiangnan[12] (central China). When he arrived in Lin Huai[13], he heard Chang Bo Xiong was an outstanding expert at boiling tea; Li Ji Qing then promptly sent a messenger to invite Chang Bo Xiong to come prepare tea. Chang Bo Xiong entered wearing fine yellow vestments and a black nobleman's hat. He immediately started laying out and arranging the

tea utensils. He conveyed the names of each tea and indicated the differences in teas. He was very methodical in the way he went about preparing tea with everyone in attendance watching intently. When the tea was ready, Li Ji Qing drank two bowls, abruptly pausing to proclaim the tea superb and worthy of royal praise.

Afterward, on his official travels, he heard that Lu Yu was also a very capable tea expert. So Li Ji Qing invited Lu Yu to prepare some tea for him. But as Lu Yu entered with tea utensils in hand, he was dressed very shoddily. His entrance lackluster, Lu Yu unceremoniously laid down tea utensils, and without a word, promptly started tea preparation. His technique in tea preparation exactly matched that of Chang Bo Xiong. However, elder statesman Li was not pleased, because of the ragged clothes Li held a low opinion and scorned Lu Yu. Moreover, Lu Yu failed to explain the differences in teas, and engage the guests as Chang Bo Xiong did. When the tea service was finished, Li Ji Qing simply ordered the servant to pay the tea waiter 30 *wen*. And that was it.

However, Lu Yu, of such famous reputation, knowing so many notable people, felt it was too great a humiliation to be labeled a "tea waiter." That caused him to write another tea book titled *Discourse on Defamed Tea*. Unfortunately this book is lost forever so we don't know much about its contents.

In later periods, because of the association of *cha boshi* with the name of Lu Yu, it became a worthy and refined title. From the Song Dynasty on, the term *cha boshi* came to mean someone well versed in tea preparation skills; during the Song, the profession of tea master was already a very highly skilled trade of employ in the cities.

Still today, particularly in Sichuan's capital, Chengdu, there are yet found many old-style teahouses throughout the city. The men in these teahouses are still known as *cha boshi*. They wield brass kettles with extremely long spouts, ready to pour hot water with exact precision into each *gaiwan* in a very artistic and skillful manner.

The term *chayi shi* on the other hand, is a very new term, only coined in the latter part of last century. This new term, "tea artist" or perhaps, even "tea arts master," however, is a recognized profession in China today, where there are many schools set up to train professional *Chayi Shi*.

TEA GUESTS

Tea guests naturally, are the customers or invited in attendance drinking tea the host prepares. But is their duty merely just to sit there and drink tea? Surely there must be more to it.

According to Huang Long De in his treatise *Discussion on Tea*, he philosophizes about the ideal tea guest:

Eight—Companions

As the tea stove disperses mist, the sound of soughing wind in the pines fills the ears. When boiling tea alone, sipping tea alone, therefore, naturally there is a kind of delight. It is not like discussing the Way with eminent scholars or chatting about poetry with poet-guests, or talking about the Profound with Yellow Caps[14],

or speaking to Black Robes[15] about Zen. In drinking tea, you can know the self, and discuss heart-to-heart, while the useless people talk of ghosts; this becomes a sickness. Similar to this, when fine guests personally attend to tea matters, after the Seventh Bowl[16] of tea is swallowed, under both armpits a refreshing breeze suddenly arises! In comparison, when sipping alone can one feel even more comfortable, happy vitality.

From Huang Long De's viewpoint, ideally, the best tea companions are none at all. Brewing and drinking tea alone is a pleasurable pursuit suitable for anyone; without need for company. Unlike engaging in complicated philosophical discussions with scholars; or matching witty verses to that of poets; or talking about the Way with Daoist priests, or even discussing Zen with Buddhist monks; instead, tea is ideally a time for quiet introspection. Tea is also time for intimate, meaningful conversation, not idle gossip about unimportant nonsense. Moreover, when many guests visit, each personally taking turns at tending to tea preparation, so much tea might be drunk, when after several bowls are finally consumed, drinking any more becomes unbearable; giving one a feeling of lightness, becoming tea drunk. For this reason, drinking alone enables one to feel a much more uplifted and joyous spirit, since one can brew and drink as one pleases, to one's own satisfaction.

In *Explanatory Notes on Tea*, Xu Ci Shu entertains the complexities of serving tea to a large crowd of guests. He states:

Discourse on Guests

When guests and friends are numerous and disorderly, people merely can toast each other. During an initial meeting of casual acquaintances, one just need offer ordinary quality tea at first. When there are guests whose inherent character are of similar tastes and interests, both parties can be genial and at ease. As for elegant discourse and eloquence, one can dispense with external appearances. From the beginning, one can call a servant to cage fire[17] (start a fire), pour water, and infuse tea. Depending on the amount of guests in attendance, for servants tea preparation is great trouble. For three people and under, only heat one stove; if there are five or six people, two stoves are convenient; use one servant; but hot water dosage per guest should be adjusted accordingly. If there is still even more hot water simultaneously made, I fear there will be mistakes. When guests become so numerous, temporarily stop the fire. One might as well in the middle of tea, allow the women to express their adoration toward male guests, and come out from the inner sanctum of the tea banquet.

Xu Ci Shu raises several interesting points. When guests and friends are too numerous, tea is not fully enjoyable; instead the entire experience merely becomes a toasting session. When receiving distant acquaintances, one may appropriately choose to use lower quality tea than that normally reserved for good friends. When host and guests have similar tastes, they may feel more comfortable together when drinking tea; without need for eloquence, without worry about impressing with striking personal appearance.

When receiving guests, depending on number of people in the party, a suf-

ficient quantity of boiled water is required. In ancient times, a servant had to first light the stove, fan the coals until red, and then set the kettle atop, waiting for water to boil. As it was a laborious, time-consuming task, it was preferable to use two stoves to heat two kettles of water simultaneously. However, when guests outnumbered the amount of water that servants could sufficiently boil, a great number of mistakes were inevitable. Becoming hopelessly impossible to brew fine tea satisfactorily to this multitude of guests; it therefore was sensible to abandon one's efforts in tea preparation.

In the *Tea Hut Chronicle*, Lu Shu Sheng advises that moral character of guests is very important. He writes:

One, Moral Character
Boiling tea is not undisciplined. The quality of a person[18] and the quality of tea must be mutually suited. Therefore its method (boiling tea) is recorded and transmitted from those of moral nobleness (eminent and outstanding people) and from the free and unrestrained (recluses) to those possessing great literary talent, calligraphers and painters, to the preeminently learned and the cultivated living in seclusion.

Tea preparation and service is a disciplined act. Tea of good quality is suited to persons of equally high moral character. Thus, scholars and officials of high moral character who retired to the mountains to live in seclusion were especially learned in the skill of tea. There are those of such high moral character who can leave the material world behind to live as recluses; then there are

those of lower moral character who continually harbor discontentment in their hearts never satisfied with fame, wealth, status, and privilege as they trudge through life in the mundane world. To learn of tea and to enjoy fine tea then requires one to be of such high moral character. When you are free from worry or preoccupation about fame, fortune, status, and image then you can enjoy the delight of stones in a cool mountain spring. It is precisely this feeling of self-contentment, peacefulness, and ease that will help you to better enjoy the true taste of tea.

APPENDIX 1: CHAPTER NOTES

Chapter 1 Notes

1. *Chá* 茶 is the character most normally used to mean tea today.
2. *Jiǎ* 檟 today is not commonly used.
3. *Shè* 蔎 today is also not commonly used.
4. *Míng* 茗 remains today as a synonym for "*cha*".
5. *Chuǎn* 荈 is also seldom used today.
6. Shu 蜀 was an ancient kingdom in what is now part of Sichuan province.
7. "Big Cloud Temple Tea Poem" 大雲寺茶詩, by Lü Yan 呂巖, a Tang dynasty tea poet. The original Chinese verse is: 玉蕊一槍稱絕品，僧家造法極功夫。
8. One Spearpoint 一槍 refers to tea buds only.
9. Flag and Spearpoint 旗槍 refers to tea made of 1 leaf and 1 bud.
10. Sparrow's Tongue 雀舌 refers to tea made of 2 leaves and a bud.
11. The original Chinese is: 石乳標奇品，瓊英碾細文。
12. Shi Ru 石乳 was a famous tea of Jianzhou in what is now the Wuyi mountain area of northern Fujian province.
13. Qiong Ying 瓊英
14. The original verse in Chinese is: 雲腴溢茗杯
15. Thick Clouds (Yun Yu) 雲腴
16. The original Chinese is: 又出鷹爪與露芽
17. Eagle Claws 鷹爪
18. Dew Buds 露芽
19. This statement is based on the fact that the first definitive records of tea go back to the Spring and Autumn period; in the *Yan Zi Chun Qiu* dated to before 500 BCE; and the Duke of Zhou's (flourished 1046 BCE) *Er Ya* dictionary. We can assume then, that tea development went back much later in time than either of these dates; so we can comfortably say tea has a history of more than 3000 years.
20. Jiang Nan 江南 was an ancient kingdom.
21. *Zhuan cha*: 饌茶 this term could also mean to drink or eat (consume) tea. In this passage, it's used as a substitute for the term "fen cha" 分茶, which more directly means parting the tea froth to create images or shapes in the froth.
22. *Chayi* 茶藝

Chapter 2 Notes

1. The list in Chinese is: Rain Water 雨水, Dew Water 露水, Sweet Dew 甘露, Sweet Nectar 甘露蜜, End of Lunar Year Snow 臘雪, Hail 雹, River Water 流水, Well Water 井泉水, Sweet Springs 醴泉, Jade Well Water 玉井水, Stalactite Cave Water 乳穴

水, Mountain Cliff Spring Water 山岩泉水, Uncooked Cooked Water 生熟湯

2. Yangzi River 揚子江, also formerly written Yangtze. The actual spring is known as Zhong Ling Quan written either as 中泠泉 or 中零泉; and also called Nan Ling Spring 南泠泉; the spring is located in Jiangsu's Zhenjiang city 鎮江市.

3. Hui Mountain 惠山 in Wuxi city 無錫市 in Jiangsu is the location of the famous Hui Mountain Spring (Hui Shan Quan) 惠山泉.

4. Tiger Hill Mountain (Hu Qiu Shan) 虎丘山 in Suzhou is the location of the famed Hu Qiu Stone spring.

5. Danyang County 丹陽縣 was the name of an ancient place around Lishui 溧水 and Jiangning 江寧 in Jiangsu.

6. Yangzhou 揚州 is in Jiangsu.

7. Wu 吳 is an ancient name for Jiangsu. The Song River 松江 runs through Suzhou 蘇州 in Jiangsu.

8. Huai River 淮江 has its source in Henan, flowing through Anhui and into Jiangsu.

9. Two Zhes refers to Eastern Zhejiang (Zhe Dong) 浙東 and Western Zhejiang (Zhe Xi) 浙西.

10. Yongjia 永嘉 is a place in Zhejiang.

11. Tonglu River 桐廬江 runs through Zhejiang.

12. Yanzi 嚴子 refers to Yanzhou 嚴州, formerly known in the Sui as Muzhou 睦州, but later changed to Yanzhou; this place is also in Zhejiang.

13. Immortal Cliff (Xian Yan) 仙岩 is located in present-day Wenzhou 溫州 in the Ouhai District 甌海區, in Zhejiang.

14. Jian Fu Temple 薦福寺 was noted for its pagoda. It was located in Chang'an in Tang times (now Xi'an in Shaanxi); constructed in 707 C.E.

15. Chu 楚 was an ancient state of the Zhou Dynasty, originally encompassing Hubei and Hunan. Later it expanded to include Henan, Anhui, Zhejiang, Jiangsu, Jiangxi, and Sichuan. Lu Yu was also from Chu.

16. Weiyang 維揚 is now the Weiyang District 維揚區 of Yangzhou 揚州 in Jiangsu.

17. Jin 晉 was an ancient state of the Zhou, encompassing the greater part of Shanxi and the southwest portion of Hebei.

18. Lu Mountain 廬山 is in Jiangxi.

19. Wuxi County 無錫縣 is in Jiangsu.

20. Qizhou 蘄州 was an ancient prefecture in present-day Hubei.

21. Xiazhou 峽州 was an ancient prefecture in present-day Hubei.

22. Suzhou 蘇州 is in Jiangsu

23. Hongzhou 洪州 was an ancient prefecture in what is now Nanchang city in Jiangxi.

24. Tangzhou 唐州 was formerly known as Huai

An Jun 淮安郡; now known as Tanghe County 唐河縣 in Henan.

25. Luzhou 盧州 was the name of an ancient place in Anhui; now known as Lu Jiang County 盧江縣.

26. Danyang County 丹陽縣 refers to an ancient place around Lishui 溧水 and Jiangning 江寧 in Jiangsu

27. Yangzhou 揚州 is in Jiangsu.

28. Jinzhou 金州 was an ancient prefecture in what is now Shaanxi.

29. Guizhou 歸州 in modern times became the town of Guizhou in Zigui County 秭歸縣, situated upriver from the Three Gorges dam area in Hubei.

30. Shangzhou 商州 is in Shaanxi. The Luo River 洛河 has its origin in Shaanxi.

31. Wu 吳 is an ancient name for Jiangsu. The Song River 松江 runs through Suzhou 蘇州 in Jiangsu.

32. Tiantai Mountain 天台山 is in Zhejiang.

33. Chenzhou 郴州 is a place in southeastern Hunan in Guiyang County 桂陽縣; situated in both the Changjiang and Pearl River basins.

34. Tonglu 桐廬 is in Zhejiang

35. Jiu Jiang 九江 is another name for Tang-era Jiang Zhou 江州. It is now known as Jiu Jiang city in Jiangxi. Jiu Jiang literally means Nine Rivers so named for the nine waters there: Gan waters 贛水 (of Ganjiang 贛江), Po waters 鄱水 (of Poyang Lake 鄱陽湖), Yu waters 余水 of Yujiang 余江, Xiu waters 修水 of Xiuhe 修河, Gan waters 淦水 or 灨水 name of a river, Xu waters 盱水, Shu waters 蜀水, Nan waters 南水, Peng waters 彭水, the name of a lake.

36. Zi 淄 and Sheng 澠 are both rivers in Shandong.

37. Moving water (*huo shui*) 活水 means moving, flowing water—calmly and always flowing water from the source. But the movement is such that it does not disturb sand and stone causing it to become turbid and muddy.

38. Plum rains 梅雨 also called Yellow Plum rains 黃梅雨, are the intermittent drizzles in the early summer rainy season (May–June) in the middle and lower reaches of the Changjiang (Yangzi) River. They are so called because this is the season when plums ripen.

The *Pi Ya* says: *Jiangsu, Hunan, and Zhejiang during the fourth and fifth months (on Chinese calendar) plums are about to turn yellow and fall. Then water moistens the earth causing mugginess. It evaporates in large quantities causing rain. This is called Plum Rains.*

《埤雅》江、湘、兩浙四五月間梅欲黃落，則水潤土溽，蒸鬱成雨，謂之梅雨。

39. *Tuan Bing* 團餅 was a kind of green tea cake used in the Song Dynasty.

40. Refined Well 丹井 means naturally distilled or filtered well water.

41. In ancient times, rainwater was gathered from the eaves of roofs; made of clay tiles. Often there is moss, grass, and other plants growing on top of the roof. When thunderstorms bring heavy rains, much of the dirt from the roof can wash away into the very large earthenware water storage jars. This is why he says the water is poisonous. The light, plum rains on the other hand, don't wash many particles into water storage jars.

42. *Fu Long Gan* 伏龍肝 literally meaning "hidden dragon liver" is in English known as *terra flava usta*, or ignited yellow earth. Alternatively called *Zao Xin Tu* 灶心土. This is the yellow scorched earth obtained by burning straw and plant stalks in the traditional Chinese cooking stove; still commonly used today. Taken internally medicinally, it is used for nausea, food poisoning, and has other uses. In ancient times the stove was likened to the body of dragons; as in the dragon kiln. Hence the name "hidden dragon liver."

43. Wulin 武林 is now Hangzhou 杭州

44. According to the Er Ya dictionary, the Yellow River has its origins in the voids of the Kunlun mountain range; originally having white waters, after descending from the mountains and reaching the flat lands, the river becomes a muddy yellow.
黃河《爾雅‧釋水》河出崑崙虛，色白，所渠并千七百，一川色黃。

45. The original 建瓶 is more properly written 建瓴.

46. Eight Merits and Virtues: Reference to Eight Merits and Virtues is found in the Guang Yu Ji :《廣輿記》鐘山八功德水，一清、二冷、三香、四柔、五甘、六潔、七不饐、八蠲痾
"Zhong Mountain Eight Merits and Virtues Water: one, clear; two, cold; three, fragrant; four, soft; five, sweet; six, clean; seven, not rancid; eight cleanse illness". The water of Zhong Mountain is attributed with these eight distinct benefits.

47. The base of Gold Mountain (Jin Shan) 金山 is where the Yangzi's Nanling Spring is found.

48. Two Zhes refers to eastern and western Zhejiang, commonly referred to as Zhe Dong 浙東 and Zhe Xi 浙西 respectively. Two capitals referred in the Han to Changan

長安 and Luoyang 洛陽; in the Ming to Beijing 北京 and Nanjing 南京. Here, it refers to the latter, literally meaning the North Capital and the South Capital. Qi 齊 refers to northern Shandong and southeastern Hebei. Lu 魯 is now Shandong. Chu 楚 refers to Hubei and Hunan. Yue 粵 refers to Guangdong and may also refer to Guangxi. Yu Zhang 豫章 is the name of an ancient prefecture in what is now Nanchang city in Jiangxi. Dian 滇 is Yunnan. Qian 黔 is another name for Guizhou.

49. Chinese make a distinction between rivers and mountain rivers. Rivers "he" 河 and "jiang" 江 are the long rivers of China, which gradually pour into the sea. "Xi" 溪 on the other hand, are narrow, winding mountain rivers. This is the distinction the author makes in the original text.

50. Da Dai Li 《大戴禮》 The original is: 陽之精氣曰神，陰之精氣曰靈。

51. Tiger Hill Stone Spring 虎丘石泉

52. Tiger Hill Mountain 虎丘山

53. China Number Three Spring 天下第三泉

54. Sword Pond 劍池

55. The original is: 又有水泉不甘能損茶味。

Chapter 3 Notes

1. Heating the fire (hou huo) 候火; the method for making fire (degree of heat, rate of burn).

2. In ancient times, wooden wheels of carts or chariots received the most toil, fatigue and strenuous use. In failing after years of use, they were split up and used as firewood; hence the term "toiled firewood". Moreover, toiled firewood had a peculiar foul smell when burning—any food cooked over it also had a peculiar odor and taste.

3. Li Yao 李約 of the Tang is seen in reference in Zhao Lin's 趙璘 *Yin Hua Lu* 《因話錄》; the second scroll states: (Li) Yao had a natural instinct to uniquely extol tea. He was very able in boiling tea. This person said: "Tea requires slow fire to roast; moving fire to boil. Moving fire is so-called charcoal fire that has a flame." "（李）約天性唯咤茶，能自煎。謂人曰：'茶須緩火炙，活火煎。'活火，謂炭火之有焰者。"

4. "Killing the scenery" is a literal translation; actually meaning to spoil the refined and dampen the spirits.

5. Sending Tea to Give to Ping Fu 寄茶與平甫. The entire poem is:
寄茶與平甫
碧月團團墮九天，封題寄與洛中仙。
石樓試水宜頻啜，金谷看花莫漫煎。
Sending Tea to Give to Ping Fu
Jade-green moon round falls from the Ninth Heaven;

A letter is sent to give to the Immortal in Luo River.

In a stone edifice trying water is suited to repeatedly sipping;

In Gold Valley looking at flowers there is none who casually boil tea.

6. Gao Er 羔兒 the name of a wine.

7. Fierce Fire 武火 is a hot, vigorous fire preferred for boiling water for tea. Gentle Fire 文火 is a cool, slow fire suitable for roasting tea.

8. Heating the water (*hou tang*) 候湯; the method and degree of boiled water.

9. Tender water 嫩湯 or simmered water is warm heated water not yet reaching a boil.

10. Dragon Phoenix Ball (*Long Feng Tuan*) 龍鳳團 was a highly-prized Imperial tribute cake tea; one of the finest teas of the Song dynasty.

11. Five Boils are shrimp eyes, crab eyes, fish eyes, joined pearls, surging spring.

12. Three Marvels 三奇 refers to Bottom Placement, Middle Placement and Upper Placement methods.

13. Controls the destiny of tea: the term used is 司命; which was an ancient reference to the stove god. It also meant anything that controls or affects destiny or fate.

14. Baby Water (*Ying Er Tang*) 嬰兒湯

15. Longevity Water (*Bai Shou Tang*) 百壽湯

16. Qin Huai 秦淮 the name of a scenic river flowing through Nanjing.

17. Tea journey 茶政 is more correctly written 茶征. It was customary in ancient times for tea scholars to wander about sampling springs and grading them; judging the quality of teas of various growing regions; hence the references to Zhang You Xin and Lu Hong Jian.

18. According to *Crane Forest Jade Dew*, it is recorded:

"Lin Nan Jin said: In the Classic of Tea, *Fish Eyes, Surging Spring, Joined Pearls are the divisions of boiling water. Then in modern times, when discussing tea, seldom is there a cauldron; a bottle is used to boil water making it hard to view the degree of boil. Therefore, there is sound distinguishing: the divisions of one boil, two boils, and three boils. In Master Lu's method, powdered tea entered the tea cauldron; therefore the second boil was an appropriate measure. However in placing powder as in today's tea infusion, a tea bowl is used to infuse tea. Then suitable hot water for use occurs between leaving the second stage and entering the start of the third boil as an appropriate measure; thus it is sound distinguishing method."*

When the water reached the end of the

second boil and just as it entered the third boil, this water temperature most suited infusing powdered green tea. Li Nan Jin composed the poem Tea Sounds to describe the sounds heard when distinguishing the degree of boil in a bottle: the first sound of boiling water is like the chirping of crickets and the drone of cicadas; the second boil like the squeaks and clatter of many loaded carts; the third boil sounds like the swooshing of winds in the pines and like the murmur of water flowing in a mountain river valley.

19. Tuan Bing 團餅 was a round, compressed cake of steamed green tea highly prized in the Song.

20. This is a quote from the poem "Miscellaneous Poetic Expressions in Tea" (Cha Zhong Za Yong) 茶中雜詠 by Pi Ri Xiu.

21. The quote is from the poem "Boiled Tea in the Examination Hall" (Shi Yuan Jian Cha) 試院煎茶 by Su Shi.

22. The quote is from Su Zi You's poem "With Zi Zhan Boiling Tea" (He Zi Zhan Jian cha) 和子瞻煎茶. Earthworms call is a metaphor for the "joined pearls" phase of boiling water. Earthworms have ringed segmented bodies, similar to a string of pearls.

23. This reference is to Li Nan Jin's poem "Tea Sounds" (Cha Sheng) 茶聲. The entire poem is:

茶聲
砌蟲唧唧萬蟬催，忽有千車捆載來。
聽得松風並潤水，急呼縹色綠瓷杯。

Tea Sounds
Crickets chirping, ten thousand cicadas hurrying; suddenly there are a thousand carts coming conveying their bundles. (This is the sound of the water as it begins to heat up in the bottle [kettle]: the faint sound of crickets and cicadas contrasted to a much louder sound as though many heavy wooden carts are passing by.)
Listening to pine winds and mountain brooks; I anxiously cry out for the light-green colored porcelain cup. (This is the sound of the water as it begins to boil inside the bottle—to the point where the water is ready; the writer then urgently requires porcelain cup [bowl] to pour out the heated water to whisk tea.)

Note, he uses the more descriptive *qi chong* 砌蟲, literally meaning bugs in stone steps. Crickets are found hiding in cracks and crevices of steps and under rocks, chirping. I translated "crickets" instead of "bugs under stone steps" for the sake of clarity.

24. Wu is the ancient name for Jiangsu. Sword Pond 劍池 is located on Tiger Hill Mountain in Suzhou.
25. Ge Ware 哥窯 was famous in Song times for the thick crackled wares produced in its kilns.

Chapter 4 Notes

1. Original Chinese is: 夏興冬廢，非飲也。
2. Original in Chinese is: 但城邑之中，王公之門，二十四器闕一，則茶廢矣。
3. Three Don't Pours, "*san bu dian*" 三不點 are conditions that are undesirable for pouring tea; Maybe a better term in English could be "Three Undesirables". Hu Zai doesn't give us much explanation to the meaning of the proverb "*san bu dian*." He only matches relevant parts of Ou Yang Xiu's poem with Su Shi's poem, giving us an idea of the three conditions desirable for drinking tea. And then he says: "This is what is meant by the proverb Three Don't Pours;" which must mean to serve as an illustrative example of the best conditions. Three Don't Pours then are exactly the opposite, undesirable conditions.
4. Ou Yang Xiu: 歐陽修 "Tasting New Tea" 《嘗新茶》The original verse is: 泉甘器潔天色好，坐中揀擇客亦佳。
5. Jie Cha 芥茶 was the name of a Ming-era tea from the lake Taihu area of Huzhou in the Changxing District, Zhejiang province. This tea grows on Luo Jie Mountain 羅芥山; which is why this tea is called Jie Tea. At that time, Feng Ke Bin was stationed in Huzhou as a Ming court official.
6. Fen Ke Bin's list of Proprieties for Tea and list of Tea Taboos are just that—lists. There was no elaboration or explanation—leaving us guessing as to the precise meaning; I provided elaboration and explained clearly what he must have meant.
7. *Qing-gong* 清供 a style of painting of the Qing Dynasty, are paintings of still-life; whose subjects are limited to natural objects such as: floral arrangements in vases, potted plants, bonsai (called "pen jing" in Chinese, literally meaning "potted landscape"), interesting natural stones, various fruit (like persimmon or tangerines), teapots, and tea cups. *Qing-gong* paintings contain much white space, while emphasizing interesting and natural shapes, their placement together, and how they complement each other. These types of paintings are mainly executed with brush and ink on rice paper, and have subdued color tones. They are often painted and

meant to be mounted as hanging scrolls, either vertically or horizontally.

8. The Way of Tea or *Cha Dao* 茶道. *Chadao* also means tea ceremony; which is of course, a very limited definition—the precise meaning and a broader definition are examined in detail in a later book on the subject.

9. Chen Ji Ru's comments on tasting tea are oft-repeated in the world of Teaism. Not only that, other Ming Dynasty tea writers have amended or expanded on his ideas.

10. The term *"cha liao"* 茶寮 in ancient Chinese just means an establishment in which to have tea, as in a teahouse. In fact, in Chinese, there are a number of words for tea drinking places, all basically reduced to just one word in English: teahouse; to make some distinctions, I translated *"cha liao"* as "tea hut" instead.

11. In Ming and Qing times, and perhaps even earlier, it was a habit to rinse the mouth with tea, or to use tea as a gargle to rid the mouth of odors. As a helpful aid to better taste flavor nuances in the tea, it's best to rinse the mouth with tea first. Tea naturally contains fluoride; absorbed from the soil; making an efficacious mouth rinse.

12. Daoist hall: In ancient China, a simple, rustic monk's hut or Daoist hall were constructed high in the mountains, surrounded by forests, rock cliffs and mountain springs. It is this idyllic surrounding to which the author refers. Indeed, in many places in southern China, these exact surroundings were perfect for tea cultivation as well, where Buddhist monks, their monasteries hidden on high mountains, shrouded in clouds, were noted for cultivating tea.

13. Discussing matters: The term *"Qing Tan"* 清談 is used—meaning either a refined discussion or theoretical discussion. The term more precisely, refers back to the period of Wei and Jin, when it was fashionable to discuss metaphysics, with topics limited to cosmology, ontology, and how cosmology fit into life. Much of this discussion advocated study of Lao Zi and Zhuang Zi. However, its advocates were criticized of doctrinairism.

14. Son of Heaven: is the title bestowed upon emperors of China.

15. Note that only the last four categories are listed here. I omitted the first three because they aren't relevant to the subject matter of this chapter.

Chapter 5 Notes

1. *Cha Li* 茶禮
2. The Chinese character *Li* 禮 has multiple definitions: rites or ceremony; or courtesy, manners, or etiquette; or gift.
3. No tea is discourteous 無茶不禮
4. Li Yun Chapter 禮運篇
5. *Li* 禮 or etiquette and *Ti* 體 or substance discussed here, have deep philosophical implications. *Li* is something intangible, while *Ti* is tangible. The idea put forth is that they are not mutually exclusive. *Ti* or substance is necessary to express *Li* or etiquette, as in sacrificial offerings. The rat obviously has a body to function; so too must people display etiquette as equally apparent as the body.
6. The *Book of Rites* states:
 祭儀篇 :
 祭不欲數，數則煩，煩則不敬。祭不欲疏，疏則怠，怠則忘。
7. Qi Kingdom 齊
8. Original in Chinese is: 靈座上，慎勿以牲為祭，但設餅果、飲茶、乾飯、酒脯而已
9. Yi Yuan 《異苑》 is a book from which Lu Yu records this account
10. Yan County 剡縣 is present-day Sheng Xian 嵊縣 in Zhejiang.
11. Fine tea: the exact wording is "fine ming" 佳茗
12. In ancient China, coins had a hole in the middle and so could be strung together neatly. This is what is meant in the story.
13. Wu Xing 吳興
14. Dunhuang 敦煌
15. Distribute Tea 分茶
16. For Tian Shen Yu Thanks for Tea List 《為田神玉謝茶表》
17. Original in Chinese is: 吳主禮賢，方聞置茗，晉臣好客，纔有分茶。
18. *Zhan* 盞 was a small, shallow bowl for drinking tea.
19. *Bai cha* 拜茶 or courtesy tea
20. Bring on some tea in Chinese is "*shang cha*" 上茶.
21. Three tea six meals 三茶六飯
22. Proffer tea 讓茶
23. See to tea 看茶
24. Wicked guests 惡客 this term can actually mean "wicked guest" or "bad guest." In any event, they are undesirable folk who would spoil the tranquil environment necessary to enjoy tea.
25. Send down tea 下茶
26. Tea Price 代茶
27. Had already drunk tea 已吃過茶
28. Receive tea 受茶
29. Accept tea 接茶
30. One family's daughter doesn't drink two families' tea 一家女不吃兩家茶

31. Never drank tea 沒吃茶
32. Implement tea 行茶
33. Tea Praise 贊茶
34. Chrysanthemum Stone (Ju Hua Shi) 菊花石
35. The original in Chinese is:《菊花石》吃過香茶要贊茶，一人領頭眾人唱，遠年風習怎能忘。
36. Kneeling tea 跪茶
37. Make noisy tea 鬧茶
38. Uniting tea 合合茶
39. Send tea 送茶
40. Seven Households Tea 七家茶
41. *Lin Qin* 林禽 in the original should actually be 林檎; Chinese pear-leaved crab apple.
42. *Qiang Wei* 薔薇 or rose; Rosa multiflora.
43. *Gui Rui* 桂蕊 might be translated as either cinnamon or osmanthus flower buds.
44. *Ding Tan* 丁檀, not the name of a particular plant, but more likely borrowed characters to mean lilac and sandalwood, which are 2 very fragrant plants, this tea being particularly fragrant.
45. *Su Xing* 蘇杏 may likely mean Jiangsu or Suzhou apricot.
46. Ge 哥 refers to the porcelain wares made at the Ge kiln; one of the five famous kilns of China. The typical Ge bowl had a thick crackled blue-green glaze.
47. Ru 汝 refers to the Ru kiln; one of the five famous kilns of China. Typically, Ru bowls were of a deep blue color.
48. New Year's Tea 年茶

Chapter 6 Notes

1. The original is: 至京邑，多開店鋪，煎茶賣之，不問道俗，投錢取飲。
2. *Cha guan* 茶館 or teahouse
3. *Cha fang* 茶坊 or tearoom
4. *Cha si* 茶肆 another term for teahouse, perhaps best translated as tea shed; a small tea shop.
5. *Cha lou* 茶樓 a storied teahouse, containing more than one floor.
6. The original in Chinese from *Water Margin* is: 第三回：史進便入城來看時，依然有六街三市，只見一個小小茶坊，正在路口。
7. *Chayi shi* 茶藝師
8. *Cha boshi* 茶博士
9. The original is: 宋江便叫茶博士將兩杯茶來。
10. Wen 文 was an ancient unit of currency.
11. The original is: 茶畢，命奴子取錢三十文，酬茶博士。
12. Jiangnan 江南
13. Lin Huai 臨淮
14. Yellow Caps refers to the yellow hats worn by Daoist priests.

15. Black Robes is a reference to Buddhist monks who wore dark garments.

16. This sentence refers to Tang poet Lu Tong's poem popularly known as "Seven Bowls of Tea;" but the poem is actually called "Quickly Penned Thanks to Meng Jian Yi for Sending New Tea." 走筆謝孟諫議寄新茶

17. Cage the fire 籠火 means to use a bamboo or metal cage to cover the fire, preventing sparks.

18. Quality of a person: meaning moral quality, or character.

APPENDIX 2: TEA BIOGRAPHIES

Bo Chu refers to Liu Bo Chu 劉伯芻 in the account in Zhang You Xin's gradings of water.

Cai Jun Mo 蔡君謨 refers to Cai Xiang 蔡襄. Jun Mo is his name of respect.

Cai Xiang 蔡襄 (1012–1067); his refined name was Jun Mo 君謨. He resided in Caicha Village 蔡垞村 in Putian 莆田; in Fujian; author of *Record of Tea*.

Chang Bo Xiong 常伯熊 was a skilled tea expert in the Tang Dynasty, perhaps even more skilled than Lu Yu.

Chen Ji Ru 陳繼儒 (1558–1639). He was a writer, painter and calligrapher; author of *Majestic Affairs on Cliff Couch* and the book *Tea Talk* (Cha Hua) 《茶話》.

Chen Jian 陳鑑 (1594–1676) his refined name was Zi Ming 子明. He was from Huazhou 化州 in Guangdong. Author of *Tiger Hill Tea Classic Annotated Amendments*.

Dai Zong 代宗 is an alternative name for Tang Emperor Li Yu 李豫, reigned from 762–779 C.E.

Dong Po is Su Dong Po 蘇東坡 or Scholar Dong Po 東坡居士 whose actual name was Su Shi 蘇軾.

Feng Ke Bin 馮可賓 his refined name was Zheng Qing 正卿; he was from Yidu 益都 in Shandong. Author of *Annotations of Jie Tea*.

Feng Yan 封演 was from Jing County 景縣 in Hebei. Compiler of the Tang record *Feng Shi Wen Jian Ji*.

Gao Bao Mian 高保勉 was the son of Gao Ji Chang.

Gao Ji Xing 高季興, also named Gao Ji Chang 高季昌, he was the founder of Jing Nan, one of ten kingdoms during the Ten Dynasties period.

Gu Yuan Qing 顧元慶 (1487–1565), author of *Tea Manual*.

Han Hong 韓翃 his refined name was Jun Ping 君平. He was from Nanyang 南陽 in Henan. Tang era poet.

Hu Zai 胡仔 (1110–1170). His pen-name was Tiao Xi Yu Yin (Hidden Fisherman of Tiao River). He was from Jixi County in Anhui province. He was a famous writer of the Southern Song dynasty; compiler of *Collected Sayings of the Hidden Fisherman of Tiao River*.

Huan Wen 桓溫 (312–373) his refined name was Master Yuan 元子. He was from Huaiyuan County 懷遠縣 in Anhui. Eastern Jin official.

Huang Long De 黃龍德 author of *Discussion on Tea*.

Huang Ting Jian 黃庭堅 (1045–1105); Northern Song poet and calligrapher. He was from Fenning 分寧 in Hongzhou 洪州; which is now Xiushui County 修水縣 in Jiangxi.

Li De Chui 李德垂

Li Ji Qing 李季卿

Li Li 李李, author of the poem "Chrysanthe-mum Stone" (Ju Hua Shi) 菊花石

Li Nan Jin 李南金 lived during the Southern Song and was good friend of Luo Da Jing.

Li Shi Zhen 李時珍 (1518–1593) author of *Outline Treatise of Materia Medica*.

Li Xu Yi 李虛已

Li Yao 李約 lived during the Tang; reference of him is in Zhao Lin's Yin Hua Lu.

Liu Bo Chu 劉伯芻, (flourished 755–815 CE); originally from Luochuan 洛川 in Shaanxi. His refined name was Su Zhi 素芝.

Lu Hong Jian 陸鴻漸 another name for Lu Yu.

Lu Na 陸納

Lu Ping Quan 陸平泉, another name for Lu Shu Sheng 陸樹聲, author of *Tea Hut Chronicle*.

Lu Shu Sheng 陸樹聲 (1509–1605). Originally from Lin Jia Jiao 林家角, which is today known as Shen Gang Zhen Lin Jia Cun 瀋巷鎮林家村 in present-day Shanghai.

Lu Yu (733–804) his refined name was Hong Jian 鴻漸. He was from Jingling 竟陵 in Fuzhou 復州 (now Tianmen 天門市 in Hubei). Middle-Tang era author of the *Classic of Tea*.

Luo Da Jing 羅大經 (1196–1252) was an official and scholar of the Song. He wrote the book *Crane Forest Jade Dew* (He Lin Yu Lu) 《鶴林玉露》. References to his work are found in *Explanation on Tea*.

Luo Lin 羅廩 (1573–1620) his refined name was Gao Jun 高君. He was from Ningbo in Zhejiang. Author of *Explanation on Tea*.

Mei Yao Chen 梅堯臣 (1002–1060), Northern Song poet. He was from Xuancheng 宣城 in Xuanzhou 宣州; which is now in Anhui.

Minister Yi 伊尹 (?–1713 BCE) was a minister and government official at the beginning of the Shang Dynasty. He was from Shen County 莘縣 in Shandong.

Ou Yang Xiu 歐陽修 (1007–1072) was originally from what is now Jiangxi province. Author of the poem "Tasting New Tea" 《嘗新茶》

Pi Ri Xiu 皮日休(834–883) Famous Late Tang writer. He was from Xiangyang 襄陽 in Hubei.

Qu Xian 癯仙 refers to Zhu Quan 朱權 of the Ming, who wrote *Tea Manual*. Qu Xian was a later name he adopted.

Scholar Six One 六一居士 is a name that Ou Yang Xiu adopted in later years.

Song Xiang 宋庠 (966–1066) his refined name was Gong Xu 公序, he was originally from Anlu 安陸 in Hubei. Song era poet.

Songtsän Gampo 松贊乾布 (617–650) Tibetan king during the Tang dynasty.

Su Shi 蘇軾 also known as Su Dong Po 蘇東坡 (1037–1101) Northern Song writer, painter and poet. He was from Meizhou 眉州; which is now Meishan 眉山 in Sichuan. Reputed author of *Chou Chi Notes*. He wrote poetic verse about Shu Well 蜀井; Shu was an ancient kingdom in present-day Sichuan province. See chapter 4.

Su Yi 蘇廙 refers to the Tang tea author of *Sixteen Qualities of Boiled Water* (Shi Liu Tang Pin) 《十六湯品》 as found in the book *Immortal Bud Commentaries* (Xian Ya Zhuan) 《仙芽傳》 written after 900 CE.

Su Zhe 蘇轍 (1039–1112) his refined name was Zi You 子由. He was from Meishan 眉山 in Meizhou 眉州, in what is now Sichuan. Northern Song era poet.

Su Zi You 蘇子由 is the refined name for poet Su Zhe 蘇轍.

Su Zi Zhan 蘇子瞻 is a refined name for famed poet Su Shi.

Tao Gu 陶穀 (903–970) was originally from Xinping 新平 in Bizhou 邠州; which is now Bin County 彬縣 in Shaanxi 陝西; author of *Chuan Ming Record*.

Tian Ru Cheng 田汝成 (1503–1557) his refined name was Shu He 叔禾. He was from Qiantang 錢塘 in Hangzhou. Author of *Extra Record of West Lake Excursion*.

Tan Yi Heng 田藝蘅 his refined name was Zi Yi 子藝, he was the son of Tian Ru Cheng. Author of *Boiled Spring Essay*.

Wang An Shi 王安石 (1021–1086) his refined name was Jie Fu 介甫. He was from Fuzhou 撫州 in Jiangxi. Song era poet, thinker, writer.

Wang Fan Zhi 王梵志 (?- d. around 670) Poet and Buddhist monk. He was from Liyang 黎陽 in Weizhou 衛州, which is now Jun County 濬縣 in Henan. Author of *Discourse Between Tea and Wine*.

Wang Jie Fu 王介甫 another name for Wang An Shi.

Wen Cheng 文成公主 (?–680) princess during the Tang dynasty.

Wen Long 聞龍. His pen-name was Hidden Fish 隱鱗. He was from Siming 四明 in Zhejiang. Author of *Annotations on Tea*.

Wu Di Xiao Ze 武帝 蕭賾 emperor of the Qi Kingdom.

Wu Run Qing 吳潤卿

Xie An 謝安

Xu Bo 徐勃 author of *Opinion on Tea*.

Xu Ci Shu 許次紓 (1549–1604) his refined name was Ran Ming 然明. He was from Qiantang in Hangzhou. Author of *Explanatory Notes on Tea*.

Xu Ran Ming 許然明 refers to Xu Ci Shu.

Yuan Jie 元結, author of *Yuan Ci Shan Ji*.

Zhang Da Fu 張大復 (1554–1630) his refined name was Xin Qi 心期. He was from Suzhou. Author of *Written Conversation of Plum Blossom Herbal Hall*.

Zhang You Xin 張又新 (flourished around 813) his refined name was Kong Zhao 孔昭. He was from Luze 陸澤 in Shenzhou 深州 in Hebei. Author of *Chronicle on Water for Brewing Tea*.

Zhang Yuan 張源. He was originally from Bao Shan 包山 in what is now Zhen Ze County 震澤縣, Jiangsu province. Author of *Record of Tea*.

Zhao Ji 趙佶 (1082–1135) also known as Song Hui Zong Zhao Ji 宋徽宗趙佶, a Song Dynasty emperor who wrote The *Da Guan Era Treatise on Tea*.

Zhao Lin 趙璘 (flourished around 844) his refined name was Ze Zhang 澤章. He was from Nanyang 南陽in Henan. Author of *Yin Hua Lu* 《因話錄》

Zhu Quan 朱權 (1378-1448) his refined name was Qu Xian 臞仙. Ming-era Daoist scholar and playwright; author of *Tea Manual*.

A Dream of Red Mansions (Hong Lou Meng) 《紅樓夢》

Annotations of Jie Tea (Jie Cha Jian)《岕茶箋》馮可賓 Feng Ke Bin circa 1642.

Annotations on Tea (Cha Jian) 《茶箋》聞龍 Wen Long, 1630.

Annotations to Er Ya (Er Ya Zhu)《爾雅注》郭璞 Guo Pu. Compiled and annotated in the Western Jin Dynasty.

Boiled Spring Essay (Zhu Quan Xiao Pin)《煮泉小品》田藝蘅 Tian Yi Heng, 1554.

Book of Rites (Li Ji) 《禮記》

Chou Chi Notes (Chou Chi Bi Ji)《仇池筆記》Written in the Song; attributed to Su Shi .

Chronicle on Water for Brewing Tea (Jian Cha Shui Ji)《煎茶水記》張又新 Zhang You Xin circa 825.

Chuan Ming Record (Chuan Ming Lu)《荈茗錄》陶穀Tao Gu. Written in the Song Dynasty 970 CE, as part of the larger corpus *Record of the Pure and Uncommon* (Qing Yi Lu)《清異錄》.

Classic of Tea (Cha Jing)《茶經》陸羽 Lu Yu. Written in the Middle Tang, 780 C.E. The first detailed study of tea in Chinese history.

Collected Sayings of the Hidden Fisherman of Tiao River (Tiao Xi Yu Yin Cong Hua) 《苕溪漁隱叢話》胡仔Hu Zai. Compilation completed in 1167.

Da Guan Era Treatise on Tea (Da Guan Cha Lun)《大觀茶論》趙佶 Zhao Ji. Written by Emperor Zhao Ji during the Da Guan (Grand View) era (1107-1110) of his reign.

Discourse Between Tea and Wine (Cha Jiu Lun)《茶酒論》王梵志 Wang Fan Zhi.

Discourse on Defamed Tea (Hui Cha Lun)《毀茶論》陸羽Lu Yu. A lost tea text.

Discussion on Tea (Cha Shuo)《茶説》Huang Long De 黃龍德, 1630.

Er Ya《爾雅》Ancient dictionary. First started in the Qin and Han periods, and completed in the Spring and Autumn and Warring States eras.

Explanation on Tea (Cha Jie)《茶解》羅廩 Luo Lin pre-1605.

Explanatory Notes on Tea (Cha Shu)《茶疏》許次紓 Xu Ci Shu, 1597.

Extra Record of West Lake Excursion (Xi Hu You Lan Zhi Yu)《西湖游覽志餘》田汝成 Tian Ru Cheng.

Feng Shi Wen Jian Ji《封氏聞見記》封演 Feng Yan. Historical record written in the Tang Dynasty.

Majestic Affairs on Cliff Couch (Yan Qi You Shi)《巖棲幽事》陳繼儒 Chen Ji Ru.

Master Lu's Spring and Autumn Annals (Lü Shi Chun Qiu)《呂氏春秋》Philosophical classic written in the Warring States era.

Opinion on Tea (Ming Tan)《茗譚》徐勃 Xu Bo, 1613.

Outline Treatise of Materia Medica (Ben Cao Gang Mu)《本草綱目》Li Shi Zhen 李時珍

Record of Tea (Cha Lu)《茶錄》蔡襄 Cai Xiang, circa 1050.

Record of Tea (Cha Lu)《茶錄》張源 Zhang Yuan circa 1595.

Seven Categories of Boiled Tea (Jian Cha Qi Lei)《煎茶七類》陸樹聲 Lu Shu Sheng.

Tea Manual (Cha Pu)《茶譜》顧元慶 Gu Yuan Qing 1541.

Tea Manual (Cha Pu)《茶譜》朱權 Zhu Quan circa 1440.

Tea Hut Chronicle (Cha Liao Ji)《茶寮記》陸樹聲 Lu Shu Sheng circa 1570.

Tiger Hill Tea Classic Annotated Amendments (Hu Qiu Cha Jing Zhu Bu)《虎丘茶經注補》陳鑒 Chen Jian, 1655.

Water Margin (Shui Hu Zhuan); also titled *Outlaws of the Marsh*《水滸傳》

Written Conversation of Plum Blossom Herbal Hall (Mei Hua Cao Tang Bi Tan)《梅花草堂筆談》

Yan Zi Chun Qiu《晏子春秋》

Yuan Ci Shan Ji《元次山集》元結 Yuan Jie, Tang Dynasty.

APPENDIX 4: ORIGINAL CHINESE TEXTS BY CHAPTER

Chapter 1
Classic of Tea, Chapter 1 "Tea Origins" (Lu Yu)《茶經· 一之源》
Five names for tea:
其名一曰茶，二曰檟，三曰蔎，四曰茗，五曰荈。

Classic of Tea, Chapter 7 "Tea Incidents" (Lu Yu)
《茶經· 七之事》
Duke of Zhou's Er Ya:
周公《爾雅》："檟，苦茶。"
Dialects:
《方言》："蜀西南人謂茶曰蔎。"
Guo Pu's Annotations on Er Ya
郭璞《爾雅注》云："樹小似梔子，冬生，葉可煮羹飲，今呼早取為茶，晚取為茗，或一曰荈，蜀人名之苦茶。"

Chuan Ming Record (Tao Gu)《荈茗錄》
Liquid Enchanter:
乳妖
吳僧文了善烹茶。游荊南，高保勉白與李興，廷置紫雲庵，日試其藝。保勉父子呼為湯神。

Creating Tea Bowl:
生成盞
饌茶而幻出物象與湯面者，茶匠通神之藝也。

沙門福全生與金鄉，長與茶海，能注湯幻茶，成一句詩。並點四甌，共一絕句，泛乎湯表。

Chapter 2
Written Conversation of Plum Blossom Herbal Hall (Zhang Da Fu)《梅花草堂筆談》
Water and tea quality:
茶性必發於水，八分之茶，遇十分之水，茶亦十分矣；八分之水，試十分之茶，茶只八分耳。

Classic of Tea, Chapter 5 "Boiling Tea" (Lu Yu)《茶經· 五之煮》
Sources of water:
其水，用山水上，江水中，井水下。《荈賦》所謂 "水則岷方之注，挹彼清流"。其山水，揀乳泉、石池慢流者上；其瀑湧湍漱，勿食之，久食令人有頸疾。又別流於山谷者，澄浸不泄，自火天至霜郊以前，或潛龍蓄毒於其間，飲者可決之，以流其惡，使新泉涓涓然，酌之。其江水，取去人遠者，井水取汲多者。

Chronicle on Water for Brewing Tea (Zhang You Xin)《煎茶水記》
Entire text:
故刑部侍郎劉公諱伯芻，於又新丈人行也。為學精博，頗有風鑑稱，較水之與茶宜者，凡七等：

揚子江南零水第一；
無錫惠山寺石泉水第二；
蘇州虎丘寺石泉水第三；
丹陽縣觀音寺水第四；
揚州大明寺水第五；
吳松江水第六；
淮水最下，第七。

斯七水，余嘗俱瓶於舟中，親挹而比之，誠如
其說也。客有熟於兩浙者，言搜訪未盡，余嘗
志之。及刺永嘉，過桐廬江，至嚴子瀨，溪色
至清，水味甚冷，家人輩用陳黑壞茶潑之，皆
至芳香。又以煎佳茶，不可名其鮮馥也，又愈
於揚子南零殊遠。及至永嘉，取仙岩瀑布用
之，亦不下南零，以是知客之說誠哉信矣。夫
顯理鑑物，今之人信不逮於古人，蓋亦有古人
所未知，而今人能知之者。
元和九年春，予初成名，與同年生期於薦福
寺。余與李德垂先至，憩西廂玄鑑室，會適有
楚僧至，置囊有數編書。余偶抽一通覽焉，文
細密，皆雜記。卷末又一題云《煮茶記》，云
代宗朝李季卿刺湖州，至維揚，逢陸處士鴻
漸。李素熟陸名，有傾蓋之歡，因之赴郡。泊
揚子驛，將食，李曰："陸君善於茶，蓋天下
聞名矣，況揚子南零水又殊絕。今者二妙，
千載一遇，何曠之乎！"　命軍士謹信者挈瓶操
舟，深詣南零。陸利器以俟之。俄水至，陸以
勺揚其水曰："江則江矣。非南零者，似臨岸
之水。"使曰："某棹舟深入，見者累百，敢
虛紿乎？"陸不言，既而傾諸盆，至半，陸遽

止之，又以勺揚之曰："自此南零者矣。"使
蹶然大駭，馳下曰："某自南零齎至岸，舟盪
覆半，懼其鮮，挹岸水增之。處士之鑑，神鑑
也，其敢隱焉！"李與賓從數十人皆大駭愕。李
因問陸："既如是，所經歷處之水，優劣精可
判矣。"陸曰："楚水第一，晉水最下。"　李
因命筆，口授而次第之：

廬山康王谷水簾水第一；
無錫縣惠山寺石泉水第二；
蘄州蘭溪石下水第三；
峽州扇子山下有石突然，洩水獨清冷，狀如龜
形，俗云蝦蟆口水，第四；
蘇州虎丘寺石泉水第五；
廬山招賢寺下方橋潭水第六；
揚子江南零水第七；
洪州西山西東瀑布水第八；
唐州柏岩縣淮水源第九，淮水亦佳；
廬州龍池山嶺水第十；
丹陽縣觀音寺水第十一；
揚州大明寺水第十二；
漢江金州上游中零水第十三，水苦；
歸州玉虛洞下香溪水第十四；
商州武關西洛水第十五；未嘗泥。
吳松江水第十六；
天台山西南峰千丈瀑布水第十七；
郴州圓泉水第十八；
桐廬嚴陵灘水第十九；
雪水第二十，用雪不可太冷。

此二十水，余嘗試之，非系茶之精粗，過此不之知也。夫茶烹於所產處，無不佳也，蓋水土之宜。離其處，水功其半，然善烹潔器，全其功也。李置諸笥焉，遇有言茶者，即示之。又新刺九江，有客李滂、門生劉魯封，言嘗見說茶，余醒然思往歲僧室獲是書，因盡篋，書在焉。古人云：「瀉水置瓶中，焉能辨淄澠。」此言必不可判也，力古以為信然，蓋不疑矣。豈知天下之理，未可言至。古人研精，固有未盡，強學君子，孜孜不懈，豈止思齊而已哉。此言亦有裨於勸勉，故記之。

Da Guan Era Treatise on Tea (Zhao Ji) 《大觀茶論》
Water　水

水以清輕甘潔為美。輕甘乃水之自然，獨為難得。古人品水，雖曰中泠、惠山為上，然人相去之遠近，似不常得。但當取山泉之清潔者。其次，則井水之常汲者為可用。若江河之水，則魚鱉之腥，泥濘之污，雖輕甘無取。凡用湯以魚目、蟹眼連繹迸躍為度。過老則以少新水投之，就火頃刻而後用。

Seven Categories of Boiled Tea (Lu Shu Sheng) 《煎茶七類》
Part Two, Tasting Springs　二品泉

泉品以山水為上，次江水，井水次之。井取汲多者，多則水活。然須旋汲旋烹。汲久宿貯者，味減鮮冽。

Record of Tea (Zhang Yuan) 《茶錄》
Tasting Springs　品泉

茶者水之神，水者茶之體。非真水莫顯其神，非精茶曷窺其體。山頂泉清而輕，山下泉清而重，石中泉清而甘，砂中泉清而冽，土中泉淡而白。流於黃石為佳，瀉出青石無用。流動者愈於安靜，負陰者勝於向陽。真源無味，真水無香。

Well Water Not Suited to Tea　井水不宜茶

茶經云：山水上，江水次，井水最下矣。第一方不近江，山卒無泉水。惟當多積梅雨，其味甘和，乃長養萬物之水。雪水雖清，性感重陰，寒入脾胃，不宜多積。

Storing Water　貯水

貯水甕須置陰庭中，覆以紗帛，使承星露之氣，則英靈不散，神氣常存。假令壓以木石，封以紙箬，曝於日下，則外耗其神，內閉其氣，水神敝矣。飲茶惟貴乎茶鮮水靈，茶失其鮮，水失其靈，則與溝渠水何異。

Explanation on Tea (Luo Lin) 《茶解》
Water　水

古人品水，不特烹時所須，先用以製團餅，即古人亦非遍歷宇內，盡嘗諸水，品其次第，亦據所習見者耳。甘泉偶出於窮鄉僻境，土人或藉以飲牛滌器，誰能省識。即余所歷地，甘泉往往有之，如象川蓬萊院後，有丹井焉，晶瑩甘厚不必淪茶，亦堪飲酌。蓋水不難於甘，而

難於厚,亦猶之酒不難於清香美列,而難於淡。水厚酒淡,亦不易解。若余中隱山泉,止可與虎跑甘露作對,較之惠泉,不免徑庭。大凡名泉,多從石中進出,得石髓故佳。沙潭為次,出於泥者多不中用。宋人取井水,不知井水止可炊飯作羹,瀹茗必不妙,抑山井耳。

瀹茗必用山泉,次梅水。梅雨如膏,萬物賴以滋長,其味獨甘。 《仇池筆記》云,時雨甘滑,潑茶煮藥,美而有益。梅後便劣,至雷雨最毒,令人霍亂。秋雨冬雨,俱能損人,雪水尤不宜,令肌肉銷鑠。

梅水須多置器,於空庭中取之,並入大甕,投伏龍肝兩許,包藏月餘汲用,至益人。伏龍肝,灶心中乾土也。

武林南高峰下有三泉,虎跑居最,甘露亞之,真珠不失下劣,亦龍井之匹耳。許然明武林人,品水不言甘露,何耶?甘露寺在虎跑左,泉居寺殿角,山徑甚僻,遊人罕至,豈然明未經其地乎。

黃河水自西北建瓶而東,支流雜聚,何所不有舟次,無名泉,聊取克用可耳。謂其源從天來,不減惠泉,未是定論。 《開元遺事》紀逸人王休,每至冬時,取冰敲其精瑩者,煮建茶以奉客,亦太多事。

Tea Manual (Zhu Quan) 《茶譜》
Evaluating Water 品水
臞仙曰:青城山老人村杞泉水第一,鐘山八功德第二,洪崖丹潭水第三,竹根泉水第四。或云:山水上,江水次,井水下。伯芻以揚子江心水第一,惠山石泉第二,虎丘石泉第三,丹陽井第四,大明井第五,松江第六,淮江第七。

又曰:廬山康王洞簾水第一,常州無錫惠山石泉第二,蘄州蘭溪石下水第三,硤州扇子硤下石窟洩水第四,蘇州虎丘山下水第五,廬山石橋潭水第六,揚子江中泠水第七,洪州西山瀑布第八,唐州桐柏山淮水源第九,廬山頂天地之水第十,潤州丹陽井第十一,揚州大明井第十二,漢江金州上流中泠水第十三,歸州玉虛洞香溪第十四,商州武關西谷水第十五,蘇州吳松江第十六,天台西南峰瀑布第十七,郴州圓泉第十八,嚴州桐廬江嚴陵灘水第十九,雪水第二十。

Explanatory Notes on Tea (Xu Ci Shu) 《茶疏》
Choosing Water 擇水
精茗蘊香,借水而發,無水不可與論茶也。古人品水,以金山中泠為第一泉,第二或曰廬山康王谷,第一廬山,余未之到,金山頂上井,亦恐非中泠古泉。陵谷變遷,已當湮沒。不然,何其漓薄不堪酌也。今時品水,必首惠泉,甘鮮膏腴,致足貴也。往三渡黃河,始憂其濁,舟人以法澄過,飲而甘之,尤宜煮茶,不下惠泉。黃河之水,來自天上,濁者土色也。澄之既淨,香味自發。余嘗言有名山則有

佳茶，茲又言有名山必有佳泉。相提而論，恐非臆說。余所經行，吾兩浙、兩都、齊魯、楚粵、豫章、滇、黔，皆嘗稍涉其山泉，味其水泉，發源長遠，而潭此澄澈者，水必甘美。即江河溪澗之水，遇澄潭大澤，味鹹甘冽。唯波濤湍急，瀑布飛泉，或舟楫多處，則苦濁不堪。蓋云傷勞，豈其恒性。凡春夏水長則減，秋冬水落則美。

Storing Water 貯水
甘泉旋汲用之斯良，丙舍在城，夫豈易得。理宜多汲，貯大甕中，但忌新器，為其火氣未退，易于敗水，亦易生蟲。久用則善，最嫌他用。水性忌木，松杉為甚。木桶貯水，其害滋甚，挈瓶為佳耳。貯水甕口，厚箬泥固，用時旋開，泉水不易，以梅雨水代之。

Ladling Water 舀水
舀水必用瓷甌。輕輕出甕，緩傾銚中。勿令淋漓甕內，致敗水味，切須記之。

Tiger Hill Tea Classic Annotated Amendments (Chen Jian)
《虎丘茶經注補》
Classic of Tea
[經]泉水上，天雨次，井水下。（注：虎丘石泉，自唐而後，漸以填塞，不得為上。而憨憨之井水，反有名。）

Amendment
[補]劉伯芻《水記》：陸鴻漸為李季卿品虎丘劍池石泉水第三。張又新品劍池石泉水第五。《夷門廣牘》謂：虎丘石泉，舊居第三，漸晶第五。以石泉泓淳，皆雨澤之積滲，竇之潢也。況闔廬墓隧，當時石工多閉死，僧眾上棲，不能無穢濁滲入。雖名陸羽泉，非天然水，道家服食，禁尸气也。

鑑欲浚劍池之水，鑿小渠流入雀澗，則泉得流而活矣。李習之謂：劍池之水不流為恨事，然哉。

Chapter 3
Classic of Tea, Chapter 5 "Boiling Tea" (Lu Yu) 《茶經· 五之煮》
Materials for fire:
其火，用炭，次用勁薪（謂桑、槐、桐、櫪之類也）其炭曾經燔炙為羶膩所及，及膏木、敗器，不用之。（膏木，謂柏、松、檜也。敗器，謂朽廢器也。）古人有勞薪之味，信哉！

Boiled Spring Essay (Tian Yi Heng)
《煮泉小品》
Discourse on Fire
有水有茶，不可無火。非無火也，有所宜也。李約云："茶須緩火炙，活火煎。"活火，謂炭火之有焰者，蘇軾詩"活火仍須活水烹"是也。余則以為山中不常得炭，且死火耳，不若枯松枝為妙。若寒月多拾松實，畜為煮茶之具更雅。

人但知湯，而不知火候，火燃則水幹，是
試火先於試水也。《呂氏春秋》：伊尹說湯五
味，九沸九變，火為之紀。

湯嫩則茶味不出，過沸則水老而茶乏。惟有花
而無衣，乃得點瀹之候耳。

唐人以對花啜茶為殺風景，故王介甫詩：
"金谷千花莫漫煎"。其意在花，非在茶也。
余則以為金谷花前信不宜矣，若把一甌對山花
啜之，當更助風景，又何必羔兒酒也。

煮茶得宜，而飲非其人，猶汲乳泉以灌蒿
藋，罪莫大焉。飲之者一吸而盡，不暇辨味，
俗莫甚焉。

Explanatory Notes on Tea (Xu Ci Shu) 《茶疏》

Heating the Fire 火候

火必以堅木炭為上。然木性未盡，尚有餘煙，
煙氣入湯，湯必無用。故先燒令紅，去其煙
焰，兼取性力猛熾，水乃易沸。既紅之後，乃
授水器，仍急扇之，愈速愈妙，毋令停手。停
過之湯，寧棄而再烹。

Record of Tea (Zhang Yuan) 《茶錄》

Heating the Fire 火候

烹茶旨要，火候為先。爐火通紅，茶瓢始上。
扇起要輕疾，待有聲稍稍重疾，斯文武之候
也。過於文則水性柔，柔則水為茶降；過於武
則火性烈，烈則茶為水製。皆不足於中和，非
茶家要旨也。

Classic of Tea, Chapter 5 "Boiling Tea" (Lu Yu) 《茶經· 五之煮》

Three Boils

其沸，如魚目，微有聲，為一沸；緣邊如湧泉
連珠，為二沸；騰波鼓浪，為三沸；已上，水
老，不可食也。

Da Guan Era Treatise on Tea (Zhao Ji) 《大觀茶論》

Boiling Water

凡用湯以魚目蟹眼連繹並躍為度。過老則以少
新水投之，就火頃刻而後用。

Record of Tea (Cai Xiang) 《茶錄》

Heating the Water 候湯

候湯最難。未熟則沫浮，過熟則茶沉，前世謂
之蟹眼者，過熟湯也。況瓶中煮之，不可辯，
故曰候湯最難。

Record of Tea (Zhang Yuan) 《茶錄》

Distinguishing the Boil 湯辨

湯有三大辨十五小辨。一曰形辨，二曰聲辨，
三曰氣辨。形為內辨，聲為外辨，氣為捷辨。
如蝦眼、蟹眼、魚眼連珠，皆為萌湯，直至湧
沸如騰波鼓浪，水氣全消，方是純熟；如初
聲、轉聲、振聲、驟聲，皆為萌湯，直至無
聲，方是純熟；如氣浮一縷、二縷、三四縷，
及縷亂不分、氤氳亂繞，皆為萌湯，直至氣直
衝貫，方是純熟。

Use of Tender or Old Hot Water 湯用老嫩
蔡君謨湯用嫩而不用老，蓋因古人製茶造則必碾，碾則必磨，磨則必羅，則茶為飄塵飛粉矣。於是和劑印作龍鳳團，則見湯而茶神便浮，此用嫩而不用老也。今時製茶，不假羅磨，全具元體。此湯須純熟，元神始發也。故曰湯須五沸，茶奏三奇。

Steep Method 泡法
探湯純熟，便取起。先注少許壺中，祛盪冷氣傾出，然後投茶。茶多寡宜酌，不可過中失正，茶重則味苦香沉，水勝則色清氣寡。兩壺後，又用冷水蕩滌，使壺涼潔。不則減茶香矣。罐熟則茶神不健，壺清則水性常靈。稍俟茶水沖和，然後分釃布飲。釃不宜早，飲不宜遲。早則茶神未發，遲則妙馥先消。

Placing Tea 投茶
投茶有序，毋失其宜。先茶後湯曰下投。湯半下茶，復以湯滿，曰中投。先湯後茶曰上投。春秋中投。夏上投。冬下投。

Explanatory Notes on Tea (Xu Ci Shu)
《茶疏》
Utensils for Boiling Water 煮水器
金乃水母，錫備柔剛，味不鹹澀，作銚最良。銚中必穿其心，令透火氣，沸速則鮮嫩風逸，沸遲則老熟昏鈍，兼有湯氣。慎之慎之。茶滋於水，水藉乎器‧湯成於火。四者相須，缺一則廢。

Brewing 烹點
未曾汲水，先備茶具。必潔必燥，開口以待。蓋或仰放，或置瓷盂，勿竟覆之。案上漆氣食氣，皆能敗茶。先握茶手中，俟湯既入壺，隨手投茶湯。叢蓋覆定。三呼吸時，次滿傾盂內，重投壺內，用以動盪香韻，兼魚不沉滯。更三呼吸頃，以定其浮薄。然後瀉以供客。則乳嫩清滑，馥郁鼻端。病可令起，疲可令爽，吟壇發其逸思，談席滌其玄衿。

Measuring Amount 秤量
茶注宜小，不宜甚大。小則香氣氤氳，大則易散漫。大約及半升，是為適可。獨自斟酌，愈小愈佳。容水半升者，量茶五分，其餘以是增減。

Boiling the Water 湯候
水一入銚，便須急煮。候有松聲，即去蓋，以消息其老嫩。蟹眼少後，水有微濤，是為當時。大濤鼎沸，旋至無聲，是為過時，過則湯老而香散，決不堪用。

Discussion on Tea (Huang Long De)
《茶說》
Six on Hot Water 六之湯
湯者，茶之司命，故候湯最難。未熟茶浮於上，謂之嬰兒湯，而香則不能出。過熟則茶沉於下，謂之百壽湯，而味則多滯。善候湯者，必活火急扇，水面若乳珠，其聲若松濤，此正湯候也。奈友吳潤卿，隱居秦淮，適情茶政，品泉有又新之奇，候湯得鴻漸之妙，可謂當今之絕技者也。

Explanation on Tea (Luo Lin)《茶解》
Boil 烹

名茶宜瀹以名泉。先令火熾，始置湯壺，急扇令湧沸，則湯嫩而茶色亦嫩。《茶經》云，如魚目微有聲為一沸，沿邊如湧泉連珠為二沸，騰波鼓浪為三沸，過此則湯老不堪用。李南金謂，當用背二涉三之際為合量。此真賞鑑家言。而羅大經懼湯過老，欲於松濤澗水後，移瓶去火，少待沸止而瀹之。不知湯既老矣，雖去火何救耶?此語亦未中竅。

芥茶用熱湯洗過擠乾。沸湯烹點，緣其氣厚，不洗則味色過濃，香亦不發耳。自餘名茶，俱不必洗。

Tea Hut Chronicle (Lu Shu Sheng)《茶寮記》
Three Boiling and Pouring Tea 三烹點

煎用活火，候湯眼鱗鱗起，沫餑鼓泛，投茶器中。初入湯少許，俟湯茗相投，即滿注。雲腳漸開，乳花浮面，則味全。蓋古茶用團餅，碾屑味易出。葉茶驟則乏味，過熟則味昏底滯。

Opinion on Tea (Xu Bo)《茗譚》
Boiling Water

古人煎茶詩摹寫湯候，各有精妙。皮日休云：時看蟹目濺，乍見魚鱗起。蘇子瞻云：蟹眼已過魚眼生，颼颼欲作松風鳴。蘇子由云：銅鐺得火蚯蚓叫。李南金云：砌蟲唧唧萬蟬催。想像此景，習習風生。

Tea Manual (Zhu Quan)《茶譜》
Water Boiling Method 煎湯法

用炭之有焰者謂之活火。當使湯無妄沸，初如魚眼散佈，中如泉湧連珠，終則騰波鼓浪，水氣全消。此三沸之法，非活火不能成也。

Annotations of Jie Tea (Feng Ke Bin)《岕茶箋》
Discussion on Boiling Tea 論烹茶

先以上品泉水滌烹器，務鮮務潔。次以熱水滌茶葉，水不可太滾，滾則一滌無餘味矣。以竹箸夾茶於滌器中，反復滌蕩，去塵土、黃葉、老梗淨，以手搦幹，置滌器內蓋定，少刻開視，色青香烈，急取沸水潑之。夏則先貯水而後入茶，冬則先貯茶而後入水。

Tiger Hill Tea Classic Annotated Amendments (Chen Jian)《虎丘茶經注補》
Five on Boiling 五之煮

［經］山水乳泉，石泓漫流者，可以煮茶。（注：陸羽來吳時，劍池未塞，想其涓涓之流。今不堪煮。）湯之候，初曰蝦眼，次曰蟹眼，次曰魚眼。若松風鳴，漸至無聲。（注：蝦蟹魚眼，言內水沸之狀也，聲如松濤，漸緩，則火候到矣。過此則老。）勿用膏薪爆炭。（注：幹炭為宜，乾松筱尤妙。）

Supplement

［補］蘇廙傳：湯者茶之司命，若名茶而濫觴，則與凡荈無異。故煎有老嫩，注有緩急，無過

不及，是為茶度。陸平泉《茶寮記》：茶用活火，候湯眼鱗鱗起，沫餑鼓泛，投茗器中，初入湯少許，使湯茗相投，即滿注，雲腳漸開，乳花浮面，則味全。蓋唐宋茶用團餅碾屑，味易出，今用葉茶，驟則味乏，過熟則昏渴沉滯矣。

［經］器用風爐、炭撾、鍑、火夾、紙袋、都籃、漉水囊、瓢碗、滌巾。

［補］錫瓶。宜興壺，粗泥細作為上。甌盞，哥窯，厚重為佳。瓶壺用草小薦，防焦漆几。

Chapter 4
Collected Sayings of the Hidden Fisherman of Tiao River (Hu Zai)
《苕溪漁隱叢話》
卷四十六
東坡九
六一居士《嚐新茶詩》云："泉甘器潔天色好，坐中揀擇客亦佳。"東坡守維揚，於石塔寺試茶，詩云："禪窗麗午景，蜀井出冰雪，坐客皆可人，鼎器手自潔。"正謂諺云"三不點"也。

Annotations of Jie Tea (Feng Ke Bin)
《岕茶箋》
Proprieties for Tea 茶宜
無事 佳客 幽坐 吟詩 揮翰 倘佯 睡起 宿醒 清供 精舍 會心 賞鑒 文僮

Seven Tea Taboos 茶忌
不如法 惡具 主客不韻 冠裳苛禮 葷有雜陳 忙冗 壁間案頭多惡趣

Majestic Affairs on Cliff Couch (Chen Ji Ru)《巖棲幽事》
Tasting Tea with Company
品茶一人得神，二人得趣，三人得味，六七人是名施茶。

Tea Manual (Gu Yuan Qing)《茶譜》
Eight Requisites for Tasting Tea
品茶八要：一品，二泉，三烹，四器，五試，六候，七侶，八勛。

Seven Categories of Boiled Tea (Lu Shu Sheng)《煎茶七類》
Four Tasting Tea 嘗茶
茶入口，先須灌漱，次復徐啜，俟甘津潮舌，乃得真味。若雜以花果，則香味俱奪矣。

Five Attending the Tea 茶候
飲茶宜凉臺靜室，明窗曲几，僧寮道院，松風竹月，宴坐行吟，清談把卷。

Six Tea Companions 茶侶
飲茶宜翰卿墨客，緇衣羽士，逸老散人，或軒冕中之超軼世味者。

Seven Tea's Merits 茶勛
除煩雪滯，滌醒破睡，譚渴書倦，是時茗碗策
勛，不減淩煙。

Record of Tea (Zhang Yuan) 《茶錄》
Tasting Tea:
飲茶以茶客少為貴，眾則喧，喧則雅趣乏矣。
獨啜曰幽，二客曰勝，三四人曰趣，五六人曰
泛，七八人曰施。

Pouring Tea:
釀不宜早，飲不宜遲。釀早則茶神未發，飲遲
則妙馥先消。

Annotations on Tea (Wen Long) 《茶箋》
飲茶日有定期：旦明、晏食、禺中、鋪時、下
春、黃昏、凡六舉，而客至烹點不與焉。

Chapter 5
Book of Rites 《禮經》
Li Yun Chapter 禮運篇
孔子曰：夫禮、先王以承天之道，以治人之
情，故失之道者死，得之者生。
詩曰：相鼠有體，人而無禮？人而無禮，胡不
遄死？

Classic of Tea, Chapter 7 "Tea Incidents"
(Lu Yu) 《茶經· 七之事》
Yi Yuan
《異苑》："剡縣陳務妻少，與二子寡居，好

飲茶茗。以宅中有古塚，每飲，輒先祀之。二
子患之曰：'古塚何知？徒以勞。'意欲掘去
之，母苦禁而止。其夜夢一人云：吾止此塚三
百餘年，卿二子恒欲見毀，賴相保護，又享吾
佳茗，雖潛壤朽骨，豈忘翳桑之報。及曉，於
庭中獲錢十萬，似久埋者，但貫新耳。母告，
二子慚之，從是禱饋愈甚。"

Discourse Between Tea and Wine (Wang
Fan Zhi) 《茶酒論》
百草之首，萬木之花。貴之取蕊，重之摘芽。
呼之茗草，號之作茶。貢五侯宅，奉帝王家。
時新獻入，一世榮華。自然尊貴，何用論誇！

Explanatory Notes on Tea (Xu Ci Shu)
《茶疏》
《茶疏· 考本》
茶不移本，植必子生。古人結昏，必以茶為
禮，取其不移置子之意也。今人猶名其禮曰下
茶。

Extra Record of West Lake Excursion
(Tian Ru Cheng) 《西湖游覽志餘· 熙朝樂事》
立夏之日，人家烹新茶，配以諸色細果，餽送
親戚比鄰，謂之七家茶。富室競侈，果皆雕
刻，飾以金箔，而湯色名目，若茉莉、林禽、
薔薇、桂蕊、丁檀、蘇杏，盛以哥汝瓷甌，僅
供一啜而已。

Chapter 6

Discussion on Tea (Huang Long De)
《茶説》

Eight Tea Companions 八之侶

茶灶疏煙，松濤盈耳，獨烹獨啜，故自有一種
樂趣。又不若與高人論道，詞客聊詩，黃冠談
玄，緇衣講禪，知己論心，散人説鬼之為愈
也。對此佳賓，躬為茗事，七碗下嚥而兩腋清
風頓起矣。較之獨啜，更覺神怡。

Explanatory Notes on Tea (Xu Ci Shu)
《茶疏》

Discourse on Guests 論客

賓朋雜沓，止堪交錯觥籌；乍會泛交，僅須常
品酬乍。惟素心同調，彼此暢適，清言雄辯‧
脫略形骸，始可呼童簧火，酌水點湯。量客多
少，為役之煩簡。三人以下，止熱一爐，如五
六人，便當兩鼎爐，用一童，湯方調適。若還
兼作，恐有參差。客若眾多，姑且罷火，不妨
中茶投果，出自內局。

Tea Hut Chronicle (Lu Shu Sheng)
《茶寮記》

One Moral Character 一人品

煎茶非漫浪，要須其人與茶品相得。故其法每
傳於高流隱逸，有雲霞泉石、磊塊胸次間者。

FURTHER READING

Cai Rong Zhang. *Chadao Rumen San Pian: Zhi Cha, Shi Cha, Pao Cha*. Beijing: Zhonghua Shu Ju, 2006.

Cai Zhen Chu and Shi Zhao Peng, eds. *Zhongguo Ming Jia Cha Shi*. Beijing: Zhongguo Nongye Chubanshe, 2003.

Cha Jun Feng and Yin Han, eds. *Cha Wenhua Yu Chaju*. Chengdu: Sichuan Kexue Jishu Chubanshe, 2003.

Chen Wen Hua, ed. *Zhonghua Cha Wenhua Jichu Zhishi*. Beijing: Zhongguo Nongye Chubanshe, 2003.

Chen Wen Hua. *Zhongguo Cha Wenhua Xue*. Beijing: Zhongguo Nongye Chubanshe, 2006.

Chen Zong Mao, ed. *Zhongguo Chajing*. Shanghai: Shanghai Wenhua Chubanshe, 1992.

Dai Sheng, Wang Xue Dian. *Li Ji*. Beijing: Lan Tian Chubanshe, 2008.

Du Tu Shidai. *Ming Shan Ming Shui Ming Cha*. Beijing: Zhongguo Qinggongye Chubanshe, 2006.

Li Wei and Li Xue Chang, eds. *Xue Chayi: Chayishi Dian Jin*. Zhengzhou: Zhong Yuan Nongmin Chubanshe, 2003.

Lian Zhen Juan. Yu Yue, ed. *Zhongguo Chaguan: Cha Wenhua Bolan*. Beijing: Zhongying Minzu Daxue Chubanshe, 2002.

Liang Duo, prod. *Chadao: Cha Li Qian Kun Da Hu Zhong Ri Yue Chang*. Dalian Yinxiang Chubanshe Youxian Gongsi, 2006.

Lin Zhi, ed. *Zhongguo Chadao: Chadao Ji Rendao, Shangdao*. Beijing: Zhonghua Gongshang Lianhe Chubanshe, 2000.

Liu Zhao Rui. *Zhongguo Gudai Yin Cha Yishu*. Xian: Shaanxi Renmin Chubanshe, 2002.

Lu Yu. *Chajing*. Beijing: Zhongguo Gongren Chubanshe, 2003.

Minsu Wenhua Bianxie Zubian. *Yin Zhi Yu*. Beijing: Hua Ling Chubanshe, 2004.

Qiao Mu Sen. *Cha Xi Sheji*. Shanghai: Shanghai Wenhua Chubanshe, 2005.

Wang Xu Feng. *Rui Cao Zhi Guo: Zhonghua Cha Wenhua Suibi*. Hangzhou: Zhejiang Daxue Chubanshe, 2001.

Yan Ying Huai and Lin Jie, eds. *Cha Wenhua Yu Pin Cha Yishu*. Chengdu: Sichuan Kexue Jishu Chubanshe, 2003.

Zhou Wen Tang. *Chadao: Shuo Cha Cong Shu*. Hangzhou: Zhejiang Daxue Chubanshe, 2003.